Master ·L· ⳍⳌ ·

and

Master ꞗꞗ

NORTHERN EUROPEAN ENGRAVERS OF THE FIFTEENTH CENTURY

Martin Schongauer, Charles Ilsley Minott

Master LCz and Master WB, Alan Shestack

The Master of the Housebook, Jane C. Hutchison

ALAN SHESTACK

Master ·L· Ⳑℨ℔·

and

Master W⚕B

Collectors Editions NEW YORK

The author and the publisher thank the following institutions for permission to reproduce the illustrations:

Amsterdam, Rijksmuseum, fig. 43; Basel, Öffentliche Kunstmuseum, fig. 41; Berlin, Staatliche Museen Berlin-Dahlem (studio: Walter Steinkopf), figs. 3, 4, 6, 11, 13, 16, 18, 31, 45; Berlin, Staatsbibliothek Preussischer Kulturbesitz, figs. 67–70; Boston, Museum of Fine Arts, fig. 15; Cologne, Kunsthaus Lempertz, fig. 35; Cologne, Rheinisches Bildarchiv, fig. 10; Darmstadt, Hessisches Landesmuseum, figs. 29, 37, 65, 66; Erlangen, Graphische Sammlung der Universitätsbibliothek, figs. 71–73; Hamburg, Hamburger Kunsthalle, figs. 42, 44; London, British Museum, fig. 9; Lugano, Galleria Thyssen, fig. 50; Mainz, Diocesan Museum (studio: Foto-Atelier Hanne Zapp), figs. 54–61; Marburg, Bildarchiv Foto Marburg, figs. 38, 39, 48, 49; Munich, Bayerisches Nationalmuseum, fig. 17; Munich, Bayerische Staatsgemäldesammlungen, figs. 26, 28, 30, 53; Munich, Staatliche Graphische Sammlung, fig. 5; New Haven, Yale University Art Gallery, fig. 8; New York, New York Public Library, Spencer Collection, fig. 75; Nuremberg, Germanisches Nationalmuseum, figs. 25, 27, 32, 34, 51; Paris, Archives Photographiques, figs. 23, 52; Paris, Bibliothèque Nationale, figs. 12, 14; Pavia, Museo Malaspina, fi~ 2; Sigmaringen, Fürstliches Hohenzollernsches Museum, Beuroner Kunstverlag, fig. 36; Vienna, Albertina, fig. 74; Washington, D.C., National Gallery of Art, Rosenwald Collection, figs. 1, 7a, 19, 40, 46, 47; Wiesbaden, Landeskonservator von Hessen, figs. 62–64.

Contents

LIST OF FIGURES

The author would like to thank the following for help in procuring photographs, for bibliographical assistance, or for helpful advice: Fedja Anzelewsky, Gisela Bergsträsser, Gisela Goldberg, Leonie von Wilckens, Horst Vey, Bernhard Saran, Alan Fern, H. Diane Russell, Eric G. Carlson, and Jay A. Levenson. Janet Beals cheerfully typed the manuscript in several drafts. My wife Nancy made numerous suggestions for improving my grammar, style, and diction. My friend and colleague Charles W. Talbot, Jr., generously agreed to read the manuscript and made invaluable suggestions for its improvement. A.S.

Introduction

IN 1922, Max Lehrs produced a volume of photogravure facsimiles of the complete engravings of Master LCz and Master WB, both German artists active in the late decades of the fifteenth century.[1] Obscured by the passage of time, the names of these two brilliant engravers had been lost to posterity and, like many other late-Gothic printmakers, they had become known only by the monograms which appear on their prints. Lehrs's volume is slim, since the surviving corpus of engravings by LCz numbers a mere twelve plates and that of WB totals only four. Because of the modest *oeuvre* of each artist and because neither could be documented or identified, no book-length study had ever been devoted to either of them.

Lehrs's decision to select these two artists from among the many anonyms of the fifteenth century and to celebrate them by reproducing their work in splendid facsimiles is due to his recognition of their high quality. Master LCz is one of the most accomplished German engravers of the decade spanning the late period of Martin Schongauer in the late 1480's and the emergence of Albrecht Dürer in the 1490's. Master WB is also one of the most intriguing German graphic artists of his time. Not only was he the only portrait engraver of the fifteenth century but, unlike other artists of the time, he placed much emphasis on psychological as well as physical realism. His insistent surface verisimilitude and his overriding concern with the personalities of his sitters clearly distinguish his engravings from the conventional, stereotyped portraits of his contemporaries.

This was not, however, Lehrs's only reason for bringing the two artists together in one volume. He observed in their prints an un-

usually high degree of originality, rare at a time when lingering medieval attitudes in Germany placed little value on innovation and when no stigma was attached to the imitation of one artist by another. He also believed that the two masters were so closely related in style and technique that their combined corpus of sixteen prints might easily have been attributed to one hand had the artists not monogrammed their engravings with two distinctive sets of initials. Lehrs noted the indebtedness of both engravers to Martin Schongauer and suggested that they were both of South German (and probably Upper Rhenish) origin. He pointed out the predisposition of both engravers to stress such elaborate ornamental details as the large jewelled object on the cap of WB's *Lady with a Jeweled Cap* (fig. 42). He also emphasized that one of LCz's engravings, the *Maiden Taming the Unicorn* (fig. 9), was a design for a pendant or locket, possibly a model for other artisans.

On this basis, Lehrs hypothesized that both engravers were goldsmiths by profession and that their goldsmiths' sensibilities ruled out the possibility that LCz and WB could have been primarily painters. As we shall demonstrate in the following pages, however, Lehrs was mistaken in seeing a close stylistic and geographical relationship between the two artists. He was also mistaken in assuming that they were goldsmiths and in denying the possibility that they were painters.

Subsequent research has shown that LCz was a Franconian artist, probably a Bamberg painter named Lorenz Katzheimer. Prior to the discovery in 1941 of this artist's name in the archives of Bamberg, a group of paintings all attributable to one hand had been assigned to an artist called the "Master of the Strache

[1] Max Lehrs, *Der Meister LCz und der Meister WB, Nachbildungen Ihrer Kupferstiche,* Berlin, 1922. One of the annual publications of the Graphische Gesellschaft.

Altarpiece." At one time a Dr. Strache from Dornach near Vienna owned three of these panel paintings (figs. 31, 33, 34), which are now dispersed, but which obviously served originally as the wings of one folding altarpiece. Max Friedländer was the first to observe, in 1916, that the three panels in the Strache collection were by the same hand that had produced the so-called *Stibar Crucifixion* (fig. 27), now in the Germanic National Museum in Nuremberg. He suggested that all these panels stemmed from one dismembered late-fifteenth-century altarpiece of Franconian origin.[2] Martin Weinberger, who saw in these panels stylistic and coloristic qualities which are peculiar to the Bamberg school, first coined the artist's nickname in the 1920's, on the basis of these four paintings.[3] He was also able to attribute two additional paintings to the master. Using the Strache panels as stylistic touchstones, scholars over the years have attributed additional panels to his hand, so that twelve pictures are now assigned to him.[4]

These paintings and the engravings of LCz have so many stylistic affinities that it can be assumed that one man is responsible for them all. Both the engravings and the paintings take their stylistic cues from painters of Nuremberg and Bamberg such as Hans Pleydenwurff, and from prints by Schongauer and the Master of the Housebook. Although a few scholars[5] still doubt that LCz and the painter of the Strache panels are one and the same, most students of late-Gothic art in Germany who have investigated the problem, notably Ernst Buchner,[6] Alfred Stange,[7] and Fedja Anzelewsky,[8] are fully convinced of the common authorship of the prints and paintings, and of the identification of LCz as Lorenz Katzheimer.

It is now known that Master WB, like LCz, was also active as a painter—one whom scholars called "The Master of the Mainz Sebastian Legend," since his major work was considered to be eight panels of scenes from the life of St. Sebastian, now in the Diocesan Museum in Mainz (figs. 54–61). The common identity of Master WB, the engraver, and the Master of the Mainz Sebastian Legend, the painter, was first noted in 1924 by Ernst Buchner.[9] Master WB was active in the Middle Rhine region, where many of his works can still be found. In addition to the Mainz paintings, a pair of painted portraits in Frankfurt (figs. 48, 49) and single portraits in Lugano (fig. 50) and Nuremberg (fig. 51), which are very close in style and spirit to the engravings, are also attributed to Master WB. The relentless verism of his painted and engraved portraits appears to show the influence of the Master of the Housebook as well as that of certain expressionistic Rhenish painters active between 1450 and 1480, especially the Master of the Coburg Roundels[10] and Hans Hirtz of Strasbourg, The Master of the Karlsruhe Passion.[11]

In addition to paintings and prints, WB also left several drawings (figs. 52, 71–73) and a copiously illustrated manuscript (figs. 67–70), preserved in the state library in Berlin. Two groups of stained-glass windows for which WB must have provided the designs also survive. One group, formerly in the parish church of Neckarsteinach, is now in the Hessischen Landesmuseum, Darmstadt (figs. 65, 66). The other group of windows, which are among the greatest stained-glass productions of late-Gothic Germany, are still *in situ* in the Marienkirche of Hanau (figs. 62, 63).

[2] Max J. Friedländer, "Ein Fränkischer Flügelaltar aus dem XV. Jahrhundert," *Ämtliche Berichte aus den Königlichen Kunstsammlungen,* XXXVIII, 1916, pp. 57–61.

[3] Martin Weinberger, *Nürnberger Malerei an der Wende zur Renaissance* (Studien zur deutschen Kunstgeschichte, 217), Strasbourg, 1921, pp. 46–51. See also Martin Weinberger, "Über die Herkunft des Meisters LCz," *Festschrift Heinrich Wölfflin,* Munich, 1924, pp. 179–82, pl. 8.

[4] Ernst Buchner, review of Thieme-Becker, *Künstlerlexikon,* XXXVII, in *Zeitschrift für Kunst,* IV, 1950, p. 322; Ernst Buchner, "Zum Malwerk des Meisters LCz," *Festgabe für Seine Königliche Hoheit Kronprinz Rupprecht von Bayern,* Munich-Pasing, 1953, pp. 85–89; Alfred Stange, *Deutsche Malerei der Gotik,* IX, Munich-Berlin, 1958, pp. 105–08.

[5] See Charles D. Cuttler, *Northern Painting from Pucelle to Bruegel,* New York, 1968, p. 315.

[6] Buchner, *Festgabe,* p. 85.

[7] Stange, *Deutsche Malerei,* IX, p. 105.

[8] Fedja Anzelewsky, "Eine spätmittelalterliche Malerwerkstatt: Studien über die Malerfamilie Katzheimer in Bamberg," *Zeitschrift des deutschen Vereins für Kunstwissenschaft,* XIX, 1965, pp. 146–50.

[9] Ernst Buchner, "Studien zur Mittelrheinischen Malerei und Graphik der Spätgotik und Renaissance: Der Meister WB," *Münchener Jahrbuch der bildenden Kunst,* N.F. IV, 1927, pp. 229–75.

[10] See Stange, *Deutsche Malerei,* IX, pls. 65–73.

[11] For reproductions of this artist's paintings see Lilli Fischel, *Die Karlsruher Passion und ihr Meister,* Karlsruhe, 1952; Stange, *Deutsche Malerei,* IV, pls. 116–120.

Thus, both LCz and WB—like Schongauer, the Housebook Master, and Albrecht Dürer—were many-sided personalities, painter-engravers who turned to printmaking between commissions for paintings in order to multiply their compositions and to serve a wide audience. By the end of the fifteenth century, engraving had been liberated from the realm of the crafts and had begun to attract the leading painters. There is no evidence that either LCz or WB was a goldsmith. If we were to accept Lehrs's contention that an artist's careful delineation of ornamental detail is evidence that he was a goldsmith, we would have to conclude also that artists like Jan van Eyck and Stephan Lochner were goldsmiths.

It is possible to speculate about the reasons why Lehrs found a stylistic similarity between LCz and WB. First, both artists must have been influenced by the prints of Schongauer and the Housebook Master. Schongauer's prints, at least, were widely circulated and widely known in the latter years of the century, and left their mark on both LCz and WB. Second, LCz's mature prints (especially fig. 14) often show people whose highly individualized and expressive features are somewhat reminiscent of the grizzled and wrinkled faces of the people in WB's engravings (figs. 41, 44). Third, both artists were essentially painters who tried to achieve with sketchy burin work the kinds of tonal values which are usually associated with painting rather than engraving.

Finally, Lehrs worked with only the limited evidence provided by the engravings. As the *oeuvres* of the two artists were expanded and their works in other media were discovered, the apparent similarities of their prints grew less significant. The general traits of period style which the two artists share, and which Lehrs emphasized, have become much less striking and have declined in importance now that we can study each artist in the perspective of the local tradition out of which his work developed.

Master ·L· ℒℨℐ·

IN 1924, Martin Weinberger first proposed that the engravings of Master LCz were closely related to Upper Franconian painting; he suggested Bamberg as a possible locale of the engraver's activity.[1] Although he studied tax records and other fifteenth-century documents in the Bamberg archives, Weinberger found mention of no artist with the appropriate initials, and he made no other relevant discoveries.[2] His theory about LCz had to rest solely on stylistic analysis. Weinberger's article received little attention, and the errors in the literature on LCz were persistently repeated. The popular notion, forwarded by Lehrs, that LCz came from South Germany had already been expressed by Kristeller[3] and Bock,[4] both of whom felt that LCz was a close follower of Schongauer in the Upper Rhine region. These scholars had contradicted the equally erroneous theory advanced in the nineteenth century by Passavant[5] and Lützow,[6] among many others, that LCz was Netherlandish. Proponents of this theory believed that the artist's curious signature, ending in "Cz," might have been an abbreviation for a common type of Netherlandish name such as "Corneliszoon." The frequently repeated suggestion that the devil in LCz's *Temptation of Christ* (fig. 19) had been inspired by Hieronymus Bosch was another erroneous argument that was advanced to support the theory that LCz was Netherlandish.

One of the most tenacious errors in the literature on Master LCz, however, is the proposal that he was the father of Lucas Cranach the Elder or that his work actually represents a phase of Cranach's career, prior to his Vienna sojourn, from about 1500 to 1505. This theory was first published by Nagler in the nineteenth century.[7] Friedrich Lippmann, although he was cautious on the subject, is reported to have believed that LCz was Cranach's father. Lehrs claims that Lippmann told him in private that the artist's monogram should be read "L Crh" rather than "LCz";[8] but the only comment on the subject that Lippmann made in print merely expressed the belief that the engravings of LCz revealed the hand of a painter rather than a goldsmith.[9] The Cranach hypothesis was repeated by Schenck-Gotha in 1947[10] and was given new authority by Max Hasse in the Thieme-Becker *Künstlerlexikon* in 1950,[11] despite the evidence presented in the convincing book on LCz published by Bernhard Saran in 1939.[12] Saran's book, although it can be faulted for attributing to LCz a number of paintings by other masters, firmly fixes LCz in the tradition of the Bamberg school and indicates his stylistic and compositional indebtedness to Hans Pleydenwurff, a Bamberg artist who worked in Nuremberg from sometime after 1457 until his death in 1472. Saran also points out some of the parallels between the Strache paintings and the LCz engravings. In spite of this and

[1] Weinberger, *Festschrift Wölfflin, passim.*

[2] Weinberger, *Festschrift Wölfflin,* p. 182, footnote 1.

[3] Paul Kristeller, *Kupferstich und Holzschnitt in vier Jahrhunderten,* 2nd ed., Berlin, 1911, p. 67.

[4] Elfried Bock, *Die deutsche Graphik,* Munich, 1922, p. 21.

[5] J. D. Passavant, *Le Peintre-Graveur,* I, Leipzig, 1860, p. 219; II, p. 288.

[6] Carl von Lützow, *Geschichte des deutschen Kupferstiches und Holzschnittes,* Berlin, 1891, p. 42.

[7] G. K. Nagler, *Die Monogrammisten,* IV, Munich, 1858–79, pp. 328–31, no. 1008.

[8] Max Lehrs, *Geschichte und Kritischer Katalog des deutschen, niederländischen, und französischen Kupferstichs im XV. Jahrhundert,* VI, Vienna, 1927, p. 320.

[9] Friedrich Lippmann, *Der Kupferstich,* 3rd ed., Berlin, 1905, pp. 45–47.

[10] Eberhard Schenck-Gotha, "Der Meister LCz," *Zeitschrift für Kunst,* I, 1947, p. 29.

[11] Max Hasse, "Meister LCz," in Thieme-Becker, *Künstlerlexikon* XXXVII, Leipzig, 1950, pp. 427–28.

[12] Bernard Saran, *Der Meister LCz, Ein Wegbereiter Albrecht Dürers in Bamberg,* 1939. As recently as 1969, the author of a survey of sixteenth-century painting in Germany and the Netherlands states that the connection between Master LCz and Lucas Cranach "is not clear." See Gert von der Osten and Horst Vey, *Painting and Sculpture in Germany and the Netherlands, 1500–1600,* Pelican History of Art, Harmondsworth, 1969, p. 132.

other evidence, the Cranach hypothesis has been so often repeated that even scholars who accept the identity of LCz as Lorenz Katzheimer often err by calling him "Lucas" Katzheimer.[13]

The major breakthrough in LCz scholarship occurred in 1941 when Konrad Arneth found in the Bamberg city archives a manuscript dated 1505 that contained a reference to a certain Lorenz Katzheimer, a painter, who was sentenced to eight days in prison because of his involvement in a brawl.[14] Arneth contended that the cantankerous artist referred to in the document must have been a close relative, either a cousin or a brother, of the well-documented painter Wolfgang Katzheimer the Elder, who is recorded in Bamberg from 1465 to 1508.[15] The monogram "Cz," according to Arneth, substitutes a Latin "C" for the German "K," and thus stands for the first and last letters of the first syllable (Katz) of the artist's surname. The substitution of "C" for "K" was common in Germany, where the letters were virtually interchangeable at that time.[16] Recently, Fedja Anzelewsky has suggested that the entire monogram represents the artist's name in Latinized form, and that the letter traditionally interpreted as a "z" is in fact a final "m" on its side, a form often encountered in Latin texts of the fifteenth century.[17] Anzelewsky further contends that in the signature on the engraving of the *Temptation of Christ* (fig. 19), the final flourish resembling a large "S" is not a whim of the artist but a standard abbreviation used in Latin texts for the ending "–us." Anzelewsky thus proposes that the monogram be understood as "L. C. . .mus," and that the name of the artist in Latin form was something like Laurentius Catzemus. Anzelewsky's idea is plausible, but it does not explain why the elaborate flourish on the monogram in the *Temptation* does not occur uniformly in the other prints, where the "z" either ends abruptly or forms a small loop (compare figs. 9, 11, 12). Anzelewsky of course did not intend to refute Arneth's arguments; indeed, he finds Arneth's thesis thoroughly convincing, and provides several additional arguments to support it.

Arneth's discovery may have been overlooked by later students of LCz [18] for several reasons, not the least of which was the fact that it was published at the very beginning of World War II and in a rather obscure journal, an annual with a small, local circulation. The discovery, however, provides strong confirmation for Weinberger's theory that LCz was a Bamberg master. Certainly the Strache paintings are so similar to the paintings of Wolfgang Katzheimer in spirit, form, coloristic peculiarities, and Morellian details, that only something like a common family or workshop affiliation could account for the resemblance.

Despite our conviction that Master LCz was Lorenz Katzheimer, we shall continue to refer to him here as "LCz," the name by which he is traditionally known. Because of scholarly habit and because it is more convenient to retain a name that has been in use for over a century, ensuring consistency in bibliographical references, none of the other anonymous engravers of the fifteenth century whose names have been discovered by twentieth-century research have yet shed their nicknames or *Notnamen* ("names of necessity").[19]

EARLY ENGRAVINGS

Of the twelve engravings by Master LCz, ten are signed, but only two are dated: the *Maiden Taming the Unicorn*, 1492 (fig. 9) and *The Sudarium Held by St. Peter and St.*

[13] See Buchner, *Festgabe,* p. 85; Friedrich Lippmann, *Der Kupferstich,* 7th ed., revised by Fedja Anzelewsky, Berlin, 1963, p. 38.

[14] Konrad Arneth, "Die Malersippe Katzheimer in Bamberg," *Wissenschaftliche Beilage zum Jahresbericht 1940–41 des Gymnasiums Bamberg,* 1941, pp. 39–44.

[15] *Ibid., passim.* See also Nils Bonsels, *Wolfgang Katzheimer von Bamberg* (Studien zur deutschen Kunstgeschichte, 306), Strasbourg, 1936.

[16] Lucas Cranach, for example, took his name from Kronach (in Saxony), his birthplace.

[17] Anzelewsky, *Zeitschrift des deutschen Vereins,* p. 148.

[18] Schenck-Gotha, *Zeitschrift für Kunst;* Hasse, in Thieme-Becker, *Künstlerlexikon.*

[19] We have known since 1903, for example, that the so-called Master of the Berlin Passion was Israhel van Meckenem's father and had the same name as his more famous son. Despite Max Geisberg's book on the subject (*Der Meister der Berliner Passion und Israhel van Meckenem,* Strasbourg, 1903), the master's nickname is still commonly used. He is never referred to as Meckenem the Elder.

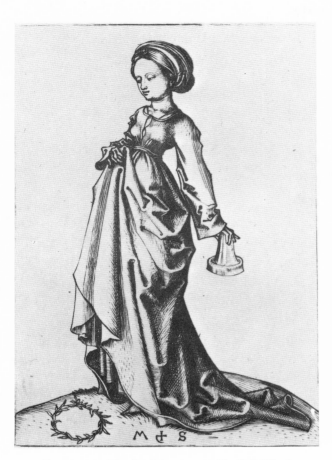

FIGURE 1 Martin Schongauer, *Foolish Virgin*, engraving, ca. 1480–83

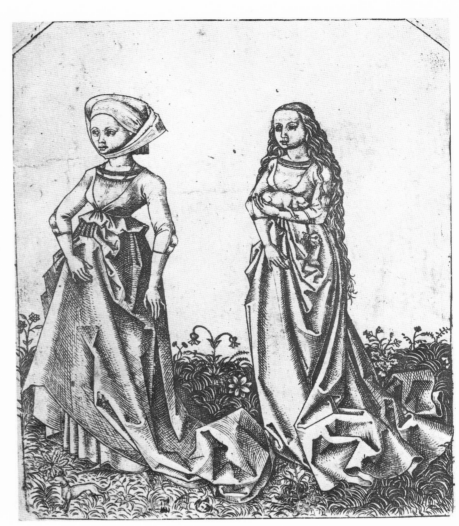

FIGURE 2 Master LCz, *Lady with a Servant in a Meadow*, engraving, ca. 1480–85

Paul, 1497 (fig. 14). It would exceed the limits of stylistic analysis to attempt to arrange the engravings in a rigid chronological sequence. So few prints by the artist survive that there may have been lapses of several years—and hence unchartable stylistic changes—between the making of one print and the next. It is possible, however, to place the prints in distinct groups and to discuss the stylistic and technical features which distinguish some of the LCz's early works from his later ones.

The engraving which appears to represent LCz's earliest style is the *Lady with a Servant in a Meadow* (fig. 2), which survives in only two known impressions, in Dresden and Pavia. The careful structuring of the drapery folds,

the stringently controlled and systematic burin work, the isolation of the figures against a blank background, the slightly mannered poses of the ladies, and even the facial types, indicate LCz's dependence at this stage upon Martin Schongauer, especially upon his series of "Wise and Foolish Virgins" (fig. 1). LCz shares Schongauer's figural types and formal language, including the characteristic high-waisted costumes and long, thin, tendril-like fingers. Schongauer's elegant, supple drapery folds, however, are transformed by LCz into something more angular and arbitrary. Furthermore, Schongauer's characteristically sweet, adolescent female is changed into a somewhat less graceful type. In LCz's print, the abundant use of hatching and the stiff, mechanical poses betray the

hand of an inexperienced artist not fully in control of his technique. Schongauer carefully regulates his crosshatching so that only the deepest hollows of drapery are described by dense linear networks; the modeling of the parts is subordinated to the overall conception. LCz over-emphasizes the neat clarity of this system of modeling to the point where it becomes much more severely methodical than it ever was in Schongauer's work. The abundance of harsh, tight lines causes the drapery to appear stiff and inflexible and imparts an austere character to LCz's print.

Schongauer's prints are all undated, but the "Wise and Foolish Virgins" are usually placed about 1480.[20] Lehrs has shown that the series must have been executed prior to 1483.[21] Since LCz's early work is clearly indebted to this Schongauer series, we have an approximate time for the beginning of LCz's active career, somewhere between 1480 and 1485.

LCz was doubtless aware of the compositional naïveté of the *Lady and Servant,* to say nothing of the archaic quality of its "landscape" setting, which derived from the stylized landscapes of Master E.S. or from paintings of the first half of the century.[22] This may account in part for his repetition of the same theme in another engraving, probably from a slightly later period, the *Two Women on a Bridge* (fig. 3). Once again a lady of high rank (indicated by the falcon she bears on her left hand) is followed by her maidservant. This time the two figures are not placed side by side in the front plane, but have emerged from a tiny castle and are walking across a log bridge toward the foreground. The artist has attempted, even on this tiny scale, to replace the rather artificial flora of the *Lady and Servant* with a realistic forest landscape. LCz's emphasis on abundant vegetation in this print and several others (figs. 4, 7) led some scholars to assume that he was a precursor of Albrecht Altdorfer, the Regensburg master. It

also served to reinforce the faulty hypothesis that he was Lucas Cranach the Elder, the most important forerunner of the Danube School. It is true that Master LCz anticipated a major characteristic of Danube School painting and printmaking, namely, the placing of human figures in nature, especially in thriving forest environments. Nowhere in LCz's work, however, do we find the kind of awesome, dynamic presence of the natural world or the organic interrelationship of man and nature that we find in the early Cranach or in the works of Altdorfer.

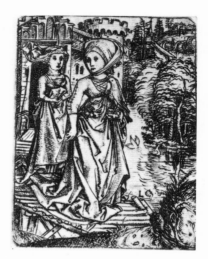

FIGURE 3 Master LCz, *Two Women on a Bridge,* engraving, ca. 1485–90

Three LCz prints can be stylistically associated with the *Two Women on a Bridge*—*St. George and the Dragon* (fig. 4), the *Flight into Egypt* (fig. 7), and the *Madonna and Child in a Window Crowned by Two Angels* (figs. 5, 6). Weinberger has suggested that these three come rather early in LCz's career and should be dated between 1485 and 1490.[23] All of these prints are characterized by a similar handling of nature, with the space filled with rocky cliffs and tree-covered hills. The burin work is somewhat harsh; short, deep, curving gouges are used to indicate the distant foliage.

[20] My date of ca. 1490 (*Fifteenth Century Engravings of Northern Europe from the National Gallery of Art,* Washington, 1967, nos. 101–104) is probably too late, and I would like to take this opportunity to state my agreement with Lehrs's earlier dating.

[21] Lehrs, *Kritischer Katalog,* V, p. 322.

[22] The Wurzacher Altarpiece of 1439 by Hans Multscher, for example, has a similar handling of "landscape."

[23] Weinberger, *Festschrift Wölfflin,* pp. 170–72.

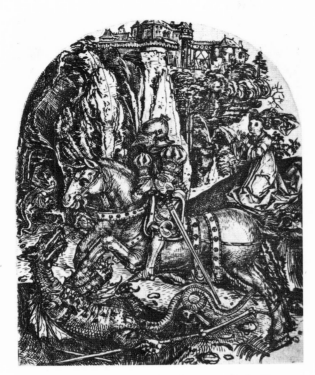

FIGURE 4 Master LCz, *St. George and the Dragon*, engraving, ca. 1485–90

The *Madonna and Child in a Window* (figs. 5, 6) is the only LCz engraving known in more than one state. The first state (fig. 5) is preserved only as a badly damaged fragment in Munich, and the second state, also unique, is in Berlin (fig. 6). It appears that the impression of the first state was carelessly removed from a book into which it had been pasted. Although it is badly torn, one can still distinguish several elements which differentiate it from the later state. The background, which consists in the first state of delicately engraved rows of trees, is further elaborated in the second state until it comes to resemble more closely the background of the *St. George* (fig. 4). There is also a major change in the face of the Madonna, which becomes much less charming due to the shortening of the mouth, the ill-conceived reworking of the eyes without distinct pupils, and the use of short, tentative lines of modeling on the cheeks. The stone sill and the corner of the brocade hanging are densely modeled in the second state, and the original monogram has been burnished out. In the second state the monogram appears in a different place, divided into two parts, the "L" on the pillar at the left, and the "Cz" at the margin on the right.

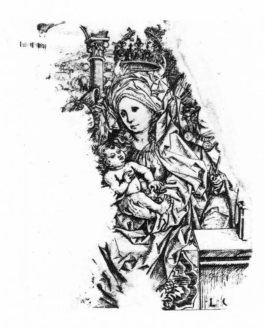

FIGURE 5 Master LCz, *Madonna and Child in a Window Crowned by Two Angels*, engraving, first state, ca. 1485–90

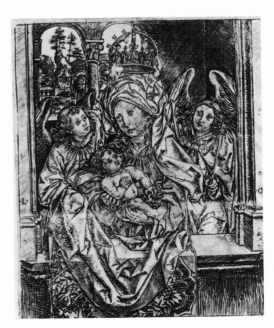

FIGURE 6 Master LCz, *Madonna and Child in a Window Crowned by Two Angels*, engraving, second state, ca. 1485–90

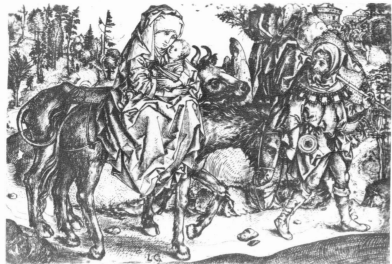

FIGURE 7 Master LCz, *Flight into Egypt*,
engraving, ca.1490

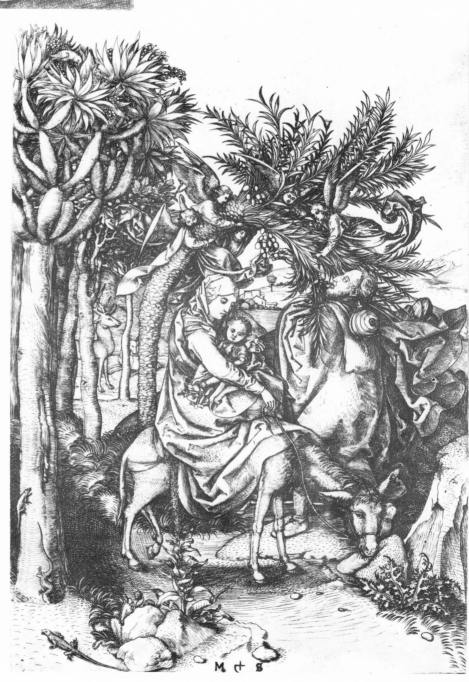

FIGURE 7a
Martin Schongauer,
Flight into Egypt,
engraving,
ca. 1470–75

The most attractive engraving of this group is the *Flight into Egypt* (fig. 7), which combines and reconciles the absolute clarity of the *Lady and Servant* (fig. 2) with the interest in complex forest settings of the *St. George* (fig. 4) and the *Two Women on a Bridge* (fig. 3). The print was probably inspired by Schongauer's *Flight into Egypt* (fig. 7a), the most famous version of the theme in German graphic art of the fifteenth century. The Madonna in LCz's print is reminiscent of Schongauer's Madonna type; she and the Child are similarly grouped and mounted on the donkey in both prints. In LCz's version, however, Joseph leads the way as the Holy Family follows a curving path across the immediate foreground. The Virgin rides on an ass which is accompanied by an ox, its familiar stablemate in nativity scenes. The background consists of a relatively sparse forest and a view of a distant castle.

This LCz engraving was probably known to Albrecht Dürer, who used the same basic arrangement around 1504 in his woodcut of the

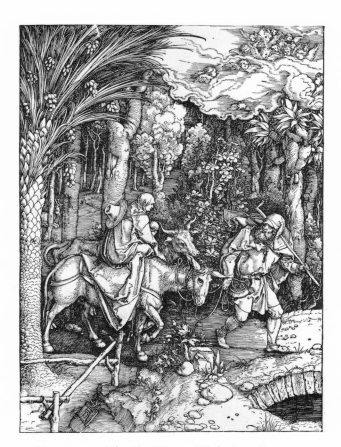

FIGURE 8 Albrecht Dürer, *Flight into Egypt*, woodcut, ca. 1504

Flight into Egypt in the "Life of the Virgin" series (fig. 8).[24] The figure of Joseph, taking a decisive step forward as he glances back to make sure that his family is safe and following close behind, is almost identical in the two prints, as is the rendering of the two beasts. Although Dürer's Madonna rides sidesaddle with her back to us, her drapery hangs over the near side of the donkey in a V-shaped configuration very similar to the configuration in LCz's print in which the Madonna faces forward. But Dürer's woodcut is in many ways more sophisticated than LCz's engraving. Dürer, for example, clarifies the spatial relationship of the two animals by obscuring the legs of the ox, avoiding the unhappy accumulation of rear limbs we encounter in LCz's print.

MIDDLE-PERIOD ENGRAVINGS

The earliest date found on an LCz print is [1]492, in the *Maiden Taming the Unicorn* (fig. 9). The print was described by Lehrs as a design for a locket or pendant, but it is more likely a design for a brooch or jeweled clasp to be worn by a young lady. In the print, a maiden surrounded by twisted gothic branches sits behind a wattle fence as a unicorn places his front hooves in her lap. The most common legend associated with the unicorn is concerned with the means of capturing the mythical beast. It was said that unicorns were so fast and fierce that they were impossible to capture except by cunning. Unicorn hunters were required to use a virgin as bait, leaving the maiden alone in a place known to be frequented by the unicorn. The beast, sensing the purity of the virgin, would come up to her and meekly lay its head in her lap. The unicorn thus came

[24] The connection was first observed by E. Tietze-Conrat, "Die Flucht nach Egypten, Eine Dürerstudie, "*Mitteilungen der Gesellschaft für Vervielfältigende Kunst,* XLIX, 1926, pp. 65–67. See also H. Tietze and E. Tietze-Conrat, *Kritisches Verzeichnis der Werk Albrecht Dürers,* I, Basel, 1937, pp. 280–81. In *Albrecht Dürer,* II, Princeton, 1943, p. 38, Panofsky claims that the LCz engraving was based on Dürer's woodcut. Panofsky's notion, however, must be incorrect, since it is not likely that the LCz *Flight into Egypt,* which is distinctly fifteenth-century in character, post-dates 1504. Furthermore, it is not likely that LCz would have confused the relation of the legs of ox and ass if he had had recourse to Dürer's model.

to symbolize purity and female chastity, and is often an attribute of the Virgin Mary as well as of female saints who were capable of resisting great temptation. For example, in Stephan Lochner's *Adoration of the Magi* in the Cologne Cathedral (fig. 10), the Virgin's mantle is held just below the neck by a jeweled clasp with the unicorn theme depicted in a manner similar to that in the design by LCz.

Two small engravings probably executed at about the same time as the *Maiden Taming the Unicorn* are the roundels of the *Crucifixion* (fig. 11) and the *Madonna Nursing the Child* (fig. 12), both about sixty millimeters in diameter. The figures in these charming and accomplished prints are set in the foreground, their drapery modeled with delicate burin strokes. Master LCz concerned himself, as always, with the problem of the relation of figure to landscape, a problem which he found difficult from the outset and which he attempted to solve by various means throughout his career.

In the *St. George* (fig. 4), the foreground figures become entangled in the background due to the undisciplined modeling which fills the surface and makes it difficult to distinguish individual parts. In the *Flight into Egypt* (fig. 7), the artist minimized the background elements in order to emphasize the figures. He evaded the problem of placing the figures *in* an environment, however, by bringing the path right out to the bottom edge of the picture.

The *Maiden Taming the Unicorn* (fig. 9) demonstrates the artist's growing sophistication. The female figure and the animal are nicely differentiated from the involved background with its complex patterns of foliage; only lightly modeled, they appear as spotlighted forms in a densely shaded space. The maiden's body is also turned at an angle to the picture plane, creating a highly convincing three-dimensional effect.

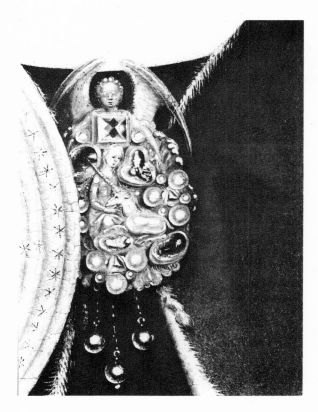

FIGURE 9 Master LCz, *Maiden Taming the Unicorn*, engraving, 1492

FIGURE 10 Stephan Lochner, *Adoration of the Magi*, panel painting, Cologne, Cathedral, ca. 1445 (detail)

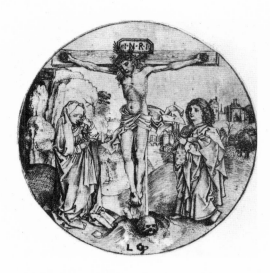

FIGURE 11 Master LCz, *Crucifixion,*
engraving, ca. 1490–92

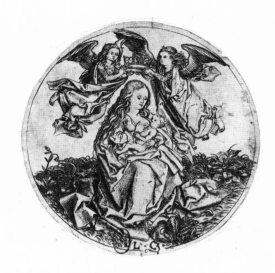

FIGURE 12 Master LCz, *Madonna Nursing
the Child,* engraving, ca. 1490–92

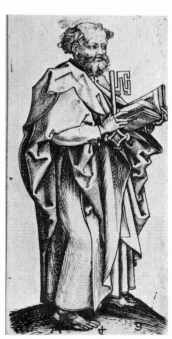

FIGURE 13 Martin Schongauer, *St. Peter,*
engraving, ca. 1480

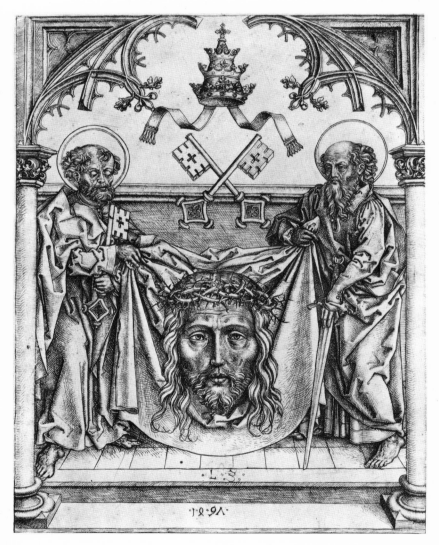

FIGURE 14 Master LCz, *The Sudarium Supported by
St. Peter and St. Paul,* engraving, 1497

The *Madonna Nursing the Child* (fig. 12)
recalls the simple garden-like setting of the
Lady with a Servant (fig. 2), although the
foliage in figure 12 has a somewhat more
naturalistic and less manicured appearance. The
modeling is also sketchier and less reminiscent
of Schongauer's systematic structuring. Like
the maiden in the *Unicorn* print, this Madonna
sits at an angle to the picture plane and has
a solid three-dimensional existence.

The *Crucifixion* (fig. 11) is probably the

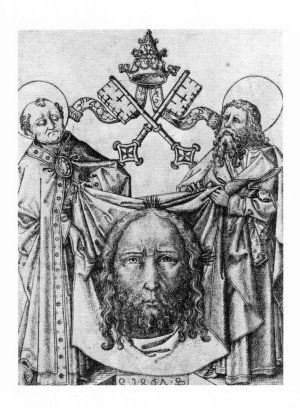

FIGURE 15 Master E. S., *The Sudarium Supported by St. Peter and St. Paul,* engraving, 1467

graving was produced in connection with the celebration of the quincentenary of the Swiss monastery of Einsiedeln, a celebration that enjoyed papal patronage.[26] LCz's retention of the papal arms in his version may, however, have been intentional and not based on a misunderstanding of their meaning in the work by E.S. The sudarium of St. Veronica was said to have been brought to St. Peter's in Rome, and it thus had a general relation to the papacy.

LCz's version deviates from the E.S. model in several ways. In the LCz print, there is a more elaborate setting for the figures, which

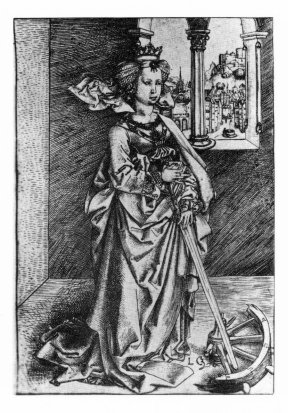

FIGURE 16 Master LCz, *St. Catherine,* engraving, ca. 1497

most successful print of this group in terms of the artist's ability to relate figures to their environment. Even in this case, however, LCz required the artificial elements of two hillocks which serve as barriers to isolate and emphasize the figures of Mary and St. John, setting them off from the delicately engraved landscape. The figure of Christ is imbued with a quiet dignity and repose, masterfully achieved considering the tiny scale of the engraving. The modeling of Christ reminds one particularly of the small Crucifixions by Schongauer, although Schongauer never achieved the tenderness of this tiny devotional image by LCz.

In 1497, LCz engraved his own version of a well-known print by Master E.S. done thirty years earlier, *The Sudarium Supported by St. Peter and St. Paul* (fig. 15). The LCz engraving (fig. 14) [25] retains the basic composition of the Master E.S. print as well as many of its elements—including the papal arms (the crossed keys and papal tiara). The E.S. en-

[25] The monogram, which appears to have been effaced by burnishing and then reworked, reads "LZ." Only the numerals 9 and 7 are engraved. In the impression in the Bibliothèque Nationale, reproduced here, the first half of the date (the numbers 1 and 4) has been added with a pen. The LZ monogram led many early students such as Nagler to the erroneous conclusion that Master LZ was a personality totally distinct from LCz.

[26] Edith W. Hoffman, "Some Engravings Executed by the Master E.S. for the Benedictine Monastery at Einsiedeln," *Art Bulletin,* XLIII, 1961, p. 236.

are placed back from the picture plane in a niche-like space framed by steps, pillars, and gothic tracery. The face of Christ imprinted on the vernicle is different, closely resembling the standard Schongauer type. It is much more sorrowful and evocative than the neutral, iconic face in the print by Master E.S. LCz must have also found the two apostle figures of Master E.S. somewhat archaic, for he modernized them by replacing them with figures derived directly from Schongauer's "Apostle" series of the 1480's (fig. 13). The rumpled drapery of the LCz apostles, with clusters of pothook folds, is derived from Schongauer,

and the pose and facial type of St. Peter are directly borrowed from Schongauer's model. Like so many fifteenth-century artists, LCz collected prints and used them as sources for motifs as well as for compositional models. The present print indicates how he was able to absorb the influences of these models and transform them into his own style. Although he borrows the figures from Schongauer and the composition from Master E.S., LCz is not a slavish imitator of either. The venerable wrinkled faces of the two figures and the emphasis on slightly unattractive naturalistic details, such as the veins in the hands and feet, are peculiar to LCz and are characteristic of his mature period.

Closely related in style to the *Sudarium* print and probably from about the same date is the *St. Catherine* (fig. 16). The drapery folds are treated very much like the folds in the cloaks of St. Peter and St. Paul and are modeled with similar systems of hatching. Lehrs mistakenly considered the *St. Catherine* to be from the early part of LCz's career, since it served as the model for a relief carving of St. Barbara on the left wing of a small portable altarpiece in the Bavarian National Museum in Munich (fig. 17) whose central panel, based on a Schongauer engraving, bears the date 1486. Lehrs reasoned that LCz's engraving must have been done prior to the altarpiece, since the altarpiece was too insignificant to have inspired copyists. Weinberger [27] was the first to observe that the 1486 date on the altarpiece could not possibly refer to its date of execution since the sculpture has the character of Swabian carving of about 1510. [28] Weinberger proposed that the date either had some importance for the original donor, or else was written on the engraving from which the carver worked and was unthinkingly copied in the sculpture. Certainly the style of the *St. Catherine* bears little resemblance to the stiff and arbitrary technique

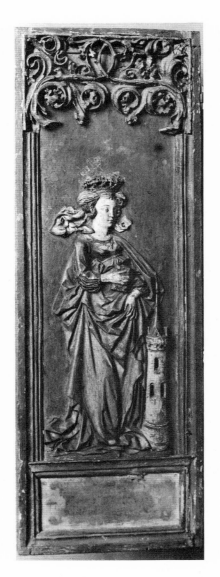

FIGURE 17 *St. Barbara,* from a carved altarpiece, Munich, Bavarian National Museum, ca. 1510

[27] Weinberger, *Festschrift Wölfflin,* p. 170.

[28] Theodor Müller dates the altarpiece about 1500–10 and believes it is of Franconian origin. See T. Müller, *Die Bildwerke in Holz, Ton, und Stein, Kataloge des Bayerischen Nationalmuseums,* XIII, 2, Munich, 1959, pp. 181–82, pl. 179.

of the *Lady and Servant* engraving (fig. 2), which we have dated about 1485. The rich yet flexible handling of the burin, the fine and compact modeling of forms, and the stately character of the figure suggest a date much closer to 1500 than to 1485. *St. Catherine* shares the style and spirit of the *Sudarium* engraving, which is dated 1497, and one feels that the two prints must have been executed at approximately the same time.

LATE ENGRAVINGS

It is generally agreed that LCz's latest engravings, representing his most mature style, are *Christ's Entry into Jerusalem* (fig. 18) and the *Temptation of Christ* (fig. 19), usually dated about 1500. The two prints are approximately the same size, 220 x 170 millimeters, and may have been intended as part of a series, never completed, of scenes from the life of Christ.

Even in his maturity, LCz turned to Schongauer for inspiration. The *Entry into Jerusalem* (fig. 18) is basically Schongaueresque, and comparison with Schongauer's *Flight into Egypt* (fig. 7a) reveals distinct parallels of form and feeling. First, the general composition is similar, with a mounted rider in exactly the same place in the center foreground. The donkey on which Christ rides resembles the one ridden by the Virgin in Schongauer's print, and the folds in the lower half of Christ's cloak, covering the donkey's middle section, are similar to the folds in the cape of Schongauer's Madonna. In the Schongauer, angels bend a palm tree so that Joseph can easily pick the dates. A palm tree is similarly placed in LCz's print, while the figure who plucks a branch from it has a profile not unlike that of Schongauer's Joseph. Finally, a little pile of rocks marks the foreground in the lower left of both engravings, and both roads curve off toward the lower right.

The *Temptation of Christ* (fig. 19), the most complex print by Master LCz, is con-

sidered one of the greatest masterpieces of early German engraving. It must have enjoyed high regard through the centuries, since twenty impressions of it have survived, more than have survived of any other print by the artist. It depicts the three temptations to which Christ was subjected by Satan (Matt. 4:1-11). After Christ was baptized, he went into the wilderness for forty days of fasting and meditation. At the end of that time, Satan came to him and said, "If you are the Son of God, command these stones to become loaves of bread." Christ replied, "Man shall not live by bread alone, but by every word that proceeds from the mouth of God." In the engraving the hideous figure of Satan, which is a conglomeration of real and fantastic anatomical elements, points to several stones with its right claw, while Christ appears resolute. According to the story in Matthew, Satan then transported Christ to the top of the Temple of Jerusalem. In the background, on top of the squat dome of the temple, we can barely detect the tiny figure of Christ surrounded by an aureole, while to the left we see the hovering figure of Satan. According to Matthew, Satan urged Christ to throw himself down to the ground, stating that if he were truly God's son, angels would bear him up. Christ replied, "You shall not tempt the Lord your God." Finally, Satan took Christ to a high mountain and showed him all the kingdoms of the world that would be his if he forsook God and prostrated himself before the Devil. Jesus answered, "Begone, Satan! For it is written, 'You shall worship the Lord your God and him only shall you serve.'" This final scene appears at the upper left of the engraving.

In the *Temptation of Christ,* LCz turned again to Master E.S. as well as to Schongauer for compositional arrangement and individual pictorial elements. The basic organization, with a dense forest on one side and a rocky cliff on the other, appears to have been inspired by Master E.S.'s *St. John on Patmos* of 1467 (fig. 20). Master LCz, however, transformed the essentially ornamental foliage of E.S. into an oak forest which appears to have been observed from nature. The little lizard which

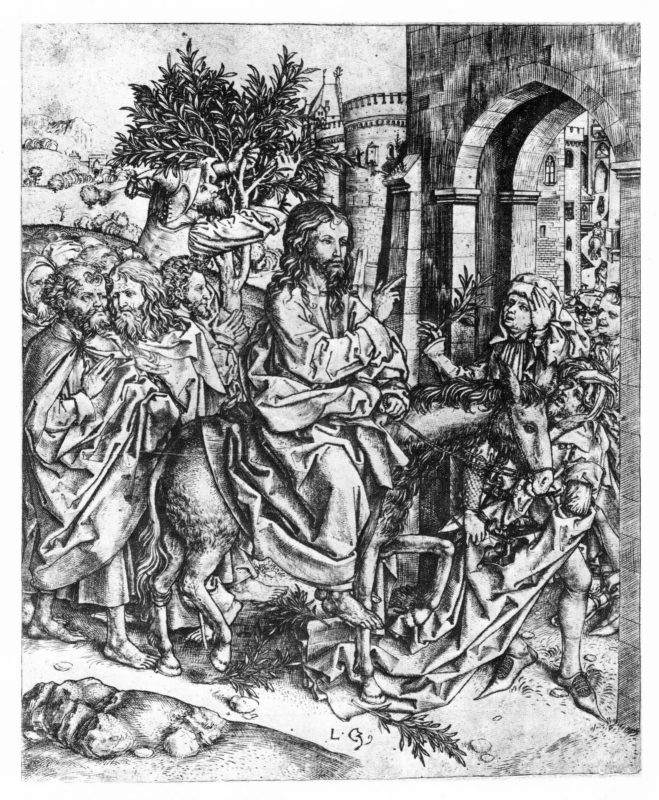

FIGURE 18 Master LCz, *Entry into Jerusalem,*
engraving, ca. 1500

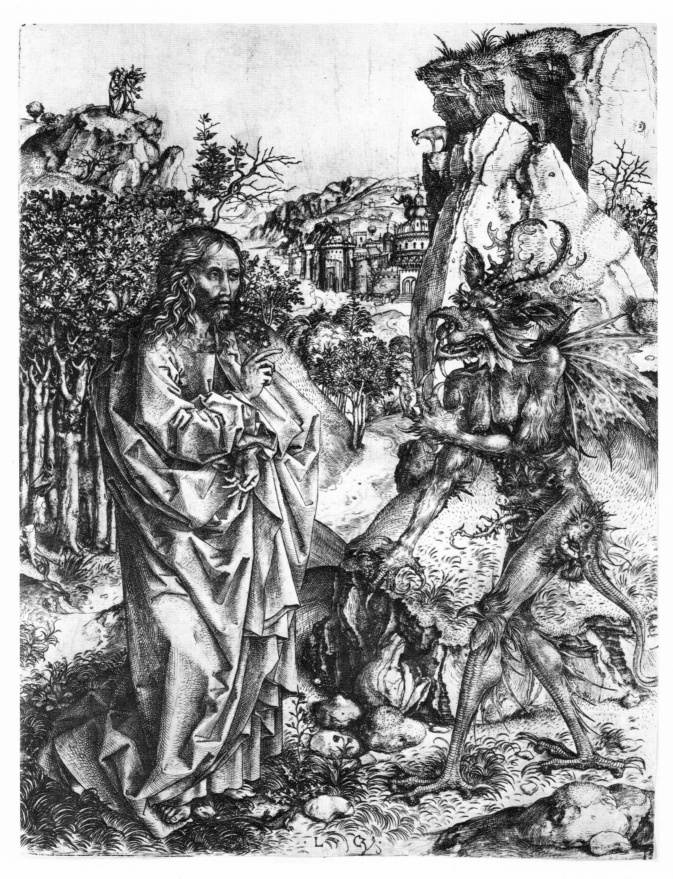

FIGURE 19 Master LCz, *Temptation of Christ,*
engraving, ca. 1500

appears at Christ's feet is borrowed from Schon-gauer's *Flight into Egypt* (fig. 7a), and the bare tree just above Christ's head is a motif frequently found in Schongauer prints. How-ever, these details are the only similarities be-tween LCz's *Temptation* and earlier German engravings. One feels that the *Temptation* is closer in mood and style to Dürer's engravings than to Schongauer's. As in Dürer's *St. Jerome* of about 1497–98 (Meder 57) or his *St. Eus-tace* of about 1501 (Meder 60), the plate is large, the lines are deeply and decisively en-graved, and the composition is self-assured

and monumental. The landscape is rich and appears to be primarily observed from nature, with only a minimal use of late-Gothic land-scape conventions. All of LCz's earlier prints had been modest in scope and had depicted single figures or small, restricted scenes. The large size and scale as well as the ambitious composition of the two latest prints reveal that LCz had developed a new concept of en-graving as a medium capable of rivaling paint-ing. The late work of Master LCz thus repre-sents a bridge between the late-Gothic aesthetic of Schongauer and the early style of Dürer.

[29]

Die funftzehend figur

FIGURE 21 Woodcut from the
Schatzbehalter, Nuremberg,
1491, probably designed
by Michael Wolgemuth

In the course of his career, LCz's work developed from a purely Gothic style (fig. 2) to a style which links his work with that of the artist who introduced the Renaissance to Germany.

Master LCz must have made frequent journeys from Bamberg to nearby Nuremberg, which was the home of Dürer and also the leading art center of Franconia in the second half of the fifteenth century. LCz may actually have come into contact with the young Dürer. He would certainly have been exposed both to the paintings of Hans Pleydenwurff and to the work of Michael Wolgemuth, Dürer's teacher, who was not only the city's leading painter in the 1480's, but was also active as a designer of woodcuts for books published in Nuremberg by Anton Koberger in the 1490's.

LCz's two late engravings (figs. 18, 19) are closely related to the Wolgemuth woodcuts in two of Koberger's books, the *Schatzbehalter* of 1491 and the *Nuremberg Chronicle* (*Weltchronik*) of 1493. LCz reinterprets the graphic vocabulary of the Wolgemuth woodcuts; but, although the engraving medium permits greater refinement, the LCz prints, with their serious facial types, choppy drapery patterns, and tangled compositions still betray a debt to Wolgemuth. The figure of Christ in the *Temptation* may have been inspired by a figure in a woodcut in the *Schaltzbehalter* depicting Moses ordaining Aaron as a priest (fig. 21). The city of Jerusalem in the engraving is composed of the same kind of Romanesque structures with crenellated towers and tiny window openings that appear in the woodcut.

The trees, grass, and rocks in the two prints are also conceived and formulated in similar ways. In addition, the figure of Moses with his serious mien, his dignified pose, and his gesture of benediction—to say nothing of the rumpled folds of his sleeve—is very similar to the figure of Christ in LCz's engraving. Indeed, Christ's gesture, the left hand in a strange cramped position and the right hand raised in the traditional attitude of blessing, makes sense only if we assume that it was copied from a figure like Wolgemuth's Moses, which holds a vessel in the left hand. LCz's brand of realism, seen in Christ's serious, frowning face, with its lined brow and deeply sunken eyes, also bears a resemblance to the characteristic type of God the Father which appears in woodcuts in Koberger's books.[29]

The juxtaposition in LCz's engraving of Christ and Satan suggests the archetypal confrontation of the forces of good and evil. Despite the abundance of drapery folds and the proliferation of flicks and strokes which model Christ's garment, the figure is contained within a simple, firm outline. Christ is thus endowed with a tectonic solidity which underscores his dignity and steadfastness, while Satan, the incarnation of everything fiendish and evil, has spiky, irregular features. Christ stands on a plot of grass and flowers, before a grove of trees, while Satan's half of the picture is barren. It is no coincidence that the trees behind Christ are oaks which, because of their firmness and endurance, are traditionally a symbol of the strength of faith and virtue.

The depiction of Satan as an unclassifiable beast, part human and part animal, is not without precedent in German art. Several of the demons in Schongauer's *Tribulations of St. Anthony* (Lehrs 54) resemble LCz's Satan. A similar confrontation between a figure in drapery and a demon appears on the reverse of Michael Pacher's *Altarpiece of the Four Church Fathers,* of about 1483, now in the Alte Pinakothek, Munich. In that scene the Devil is sub-

dued by St. Wolfgang and forced to hold St. Wolfgang's missal.[30]

The little goat or ibex which appears on the side of the cliff in the background of LCz's *Temptation* has been the subject of much dispute. It is a symbol of the unbelieving, and it appears in scenes of temptation or in scenes that distinguish between the saved and the damned. Lehrs originally suggested that LCz borrowed this detail from Dürer's *Adam and Eve* of 1504 (fig. 22), and that LCz's *Temptation* therefore postdates the Dürer.[31] E. Tietze-Conrat believed that the reverse was more

FIGURE 22 Albrecht Dürer, *Adam and Eve,* engraving, 1504 (detail)

likely true and that Dürer had been captivated by the detail in LCz's print and copied it.[32] Neither supposition is correct. LCz's goat is actually a reversed copy from a woodcut in Thomas Lirer's *Swabian Chronicle (Chronik von allen Königen und Kaisern)* of 1486, published by Konrad Dinckmut of Ulm (fig. 23). The goat in the Ulm woodcut corresponds to LCz's goat in all details, including the placement on the rock ledge and the shading of the rocks just below. Dürer's goat is entirely different from the two earlier versions.

LCz's two late engravings (figs. 18, 19) contain several stylistic parallels to the paintings of the Strache Altarpiece, especially to the *Flagellation* (fig. 33), now in the Louvre. These comparisons provide basic evidence for identifying the painter and engraver as the same

[29] Compare Albert Schramm, *Der Bilderschmuck der Frühdrücke,* XVII, Leipzig, 1920–43, pl. 109, nos. 317–318.

[30] Reproduced in Eberhard Hempel, *Das Werk Michael*

Pachers, 6th ed., Vienna, 1952, pl. 87; Nicolo Rasmo, *Michael Pacher,* Munich, 1969, pl. 68.

[31] Max Lehrs, "The Master LCz," *Print Collector's Quarterly,* IX, 1922, pp. 8–9.

[32] E. Tietze-Conrat, *Mitteilungen,* pp. 65–67.

person. The figure and facial types are virtually identical. One can compare, for example, the spectator in the window in the upper right corner of the *Flagellation* or the man with outstretched arms in the *Christ Before Pilate* (fig. 31) with the chubby man in the engraving of the *Entry into Jerusalem* (fig. 18) who stands in the city gateway holding a palm branch. The turbaned figure in this engraving, who spreads out his coat on the ground for Christ, is very similar to the turbaned tormentor in the *Flagellation* painting. The faces of these last two figures are nearly identical; both have the same heavily lidded eyes and the same partly open mouths that expose the upper teeth. Furthermore, the drapery in the *Entry,* which is cast into masses of angular folds with the appearance of a crisply starched fabric, is

identical in character to the drapery in the paintings. The square-ended folds and cuff of Christ's sleeve in the *Bearing of the Cross* (fig. 34) can be compared to those of the sleeve of Christ's garment in the *Entry.* The same arrangement of sleeve and cuff occurs again in the painting of *Christ on the Mount of Olives* (fig. 29).

A clear comparison can also be made between the drapery in the engraving of the *Temptation* (fig. 19) and the painting of *Christ before Pilate* (fig. 31), where the small folds on Christ's sleeves are represented in very similar ways, and the large folds of his cloak form long, narrow, and rather deep crevices. The architectural form of the city gate in the *Entry* engraving, with its blocks of alternating dark and light tones, can be compared with the masonry arrangement in the structure at the right of the *Bearing of the Cross*.[33] Perhaps the

[33] Another LCz print which shows an architectural analogy to the *Bearing of the Cross* (fig. 34) is the *Madonna and Child in a Window* (fig. 6), where the two visible columns are surmounted by a flat, geometrical capital on the left and a foliate Corinthian capital on the right, just as are the columns in the bipartite window of the Berlin painting.

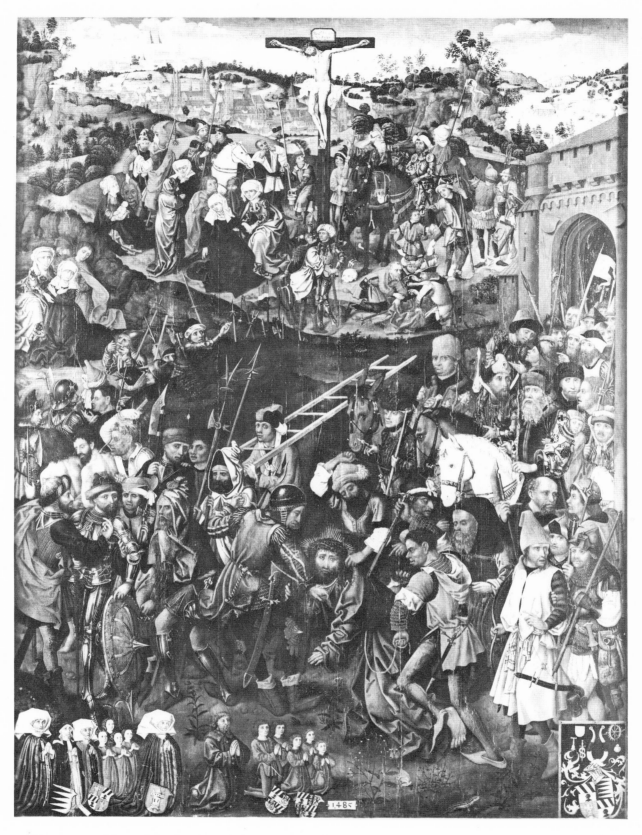

FIGURE 25 Master LCz, *Bearing of the Cross to Calvary,*
panel painting, Nuremberg, Church of St. Sebald, 1485

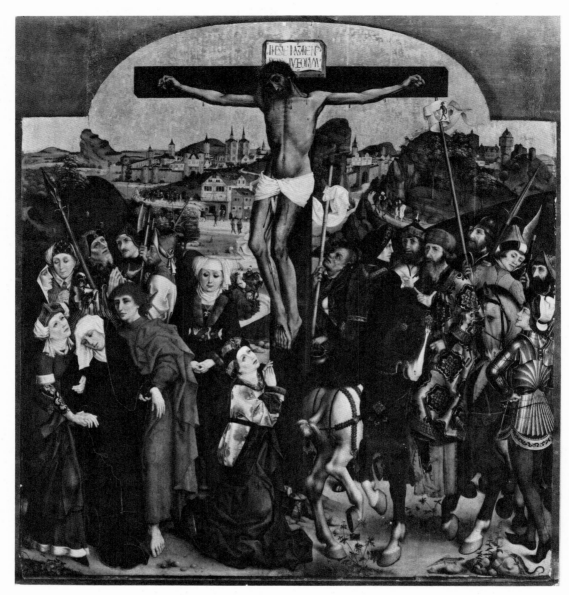

FIGURE 26 Hans Pleydenwurff, *Calvary,*
panel painting, Munich, Alte Pinakothek,
ca. 1470

clearest connection between the *Entry* and the
Strache paintings can be seen in the recurring
type of Christ's face—with its long thin nose,
carefully delineated lips, short beard, and
stringy hair. The face of Christ in the *Entry* is
particularly close to the one in the Darmstadt
Mount of Olives (fig. 29). Another point that
can be compared in the engravings and the
paintings is the artist's treatment of hands and
feet which are plump and fleshy and which
always display bulging veins. The figures in
LCz's late prints make expressive use of their
hands and, like the figures in the Strache paint-
ings, underline the meaning of the narrative
through emphatic gestures.

PAINTINGS

The earliest painting attributed to Master
LCz is the *Bearing of the Cross to Calvary,*
dated 1485, in the church of St. Sebald in
Nuremberg (fig. 25). The main foreground
group of Christ and his tormentors is taken
directly from Schongauer's early *Bearing of
the Cross* (fig. 24), while the group of riders
in the right foreground and also those at the
base of the cross in the middle distance recall
the figures in Hans Pleydenwurff's *Crucifixion*

in Munich (fig. 26). Weinberger,[34] who was the first to attribute the 1485 *Calvary* painting to the Strache Master, noted that Pleydenwurff's conception of the horse was adopted by the Strache painter. For example, the horse with the white markings on the face and muzzle in the Pleydenwurff reappears in the LCz painting at the right of the cross. Like Pleydenwurff's horses, LCz's horses seem to smile and glance coyly out of the picture.

Several other factors—besides the artist's obvious indebtedness to Schongauer and Pleydenwurff—make it clear that the 1485 painting is an early work. The vertical accumulation of elements and their seemingly haphazard arrangement betrays the artist's lack of experience. In addition, spaces are treated in isolation with no apparent unifying compositional scheme and no interdependence of parts. As in the engraving of the *Lady and Servant* (fig. 2), which we dated about 1485 on stylistic grounds, the figures are conceived individually as if they were independent studies, and the drapery folds are stiff and arbitrary. The donor family at the bottom left is that of Hans Tucher (1426–91), with his first wife, Barbara Ebner, and his second wife Ursula Harsdörffer, together with all the children of both marriages. Apparently the wife of Hans's eldest son is also included. The device in the lower right corner is Hans Tucher's coat of arms.

Since the Tuchers were a notable patrician family of Nuremberg, this painting was formerly ascribed to various Nuremberg artists. The accurate rendering of the silhouette of Bamberg on the horizon, however, makes it more likely that a Bamberg artist executed the painting. Weinberger speculated that Tucher desired a painting in a conservative style, a style no longer followed in Nuremberg by 1485, and that he turned to a master of more provincial Bamberg, where the older traditions still persisted.[35] The St. Sebald painting has all of the coloristic signs of Bamberg paintings, with their emphasis on deep blues, wine-reds,

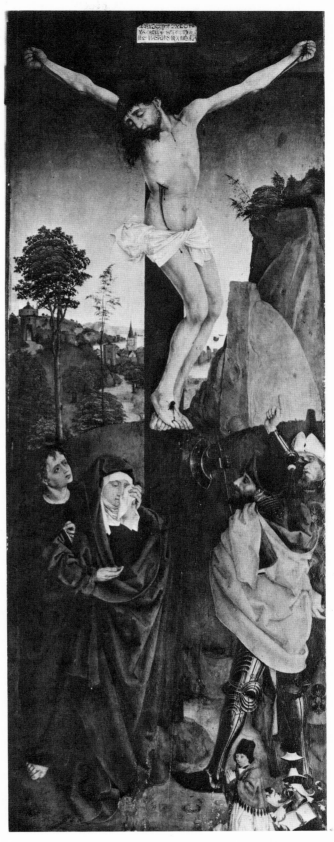

FIGURE 27 Master LCz, *Stibar Crucifixion,* panel painting, Nuremberg, Germanic National Museum, ca. 1485–90

[34] Weinberger, *Nürnberger Malerei,* p. 50.

[35] Weinberger, *Nürnberger Malerei,* p. 51. See also Ludwig Grote, *Die Tucher, Bildnis einer Patrizierfamilie,* Munich, 1961, pp. 63–64, pls. 13–17. A watercolor in East Berlin reproduced by Grote (pl. 16) may be a preliminary study for the Nuremberg painting.

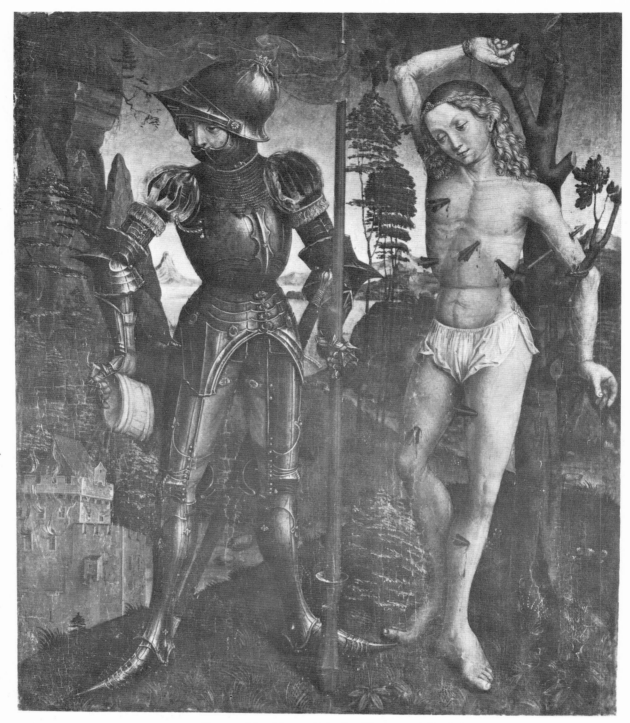

FIGURE 28 Master LCz, *St. Florian and St. Sebastian,* panel painting,
Schloss Burghausen (Bavarian State Painting Collection), ca. 1485–90

violets, greens, and greys. As in all of the
Strache paintings the flesh tones are under-
painted with light blue. It should be noted, by
the way, that the St. Sebald painting has suf-
fered damage through the centuries and is also
discolored by several layers of darkened var-
nish. To add to the student's difficulties, the

painting is presently located high on a pillar
in the shadowy Sebalduskirche.

Master LCz's ability to organize and artic-
ulate figures in a spatial setting soon improved
significantly, as we can see in another small
panel from his early period, a *Crucifixion* (fig.

27) now in Nuremberg.[36] The donor kneeling at the lower right has been identified as Johann Stibar von Buttenheim, canon of Bamberg Cathedral, who died in 1487. This painting often appears in the literature as the *Stibar Crucifixion*. The date of the donor's death provides an approximate date for the painting, sometime in the middle or late 1480's. Like the St. Sebald painting, the basic tone of this picture is blue, with patterns of subtly differentiated reds, violets, and light green. As in the small engraved *Crucifixion* (fig. 11), the figures are arbitrarily separated from the background by the presence of rounded hillocks. The drapery of St. John's garments, especially the sleeve folds, is similar to the drapery of Christ's garments in the *Temptation* (fig. 19); and St. John's foot protrudes from under his garment in an identical manner. The facial type of the Christ on the Cross anticipates the type encountered in the Strache panels (figs. 31, 33, 34, and 35).

Of the same period as the *Stibar Crucifixion* is a small painting of *St. Sebastian and St. Florian* (fig. 28) acquired by the Bavarian State Collection just prior to World War II; it now hangs in the gallery of Schloss Burghausen in Bavaria. The figure of Sebastian is based on Schongauer's small *St. Sebastian* engraving (Lehrs 64). The armor of St. Florian resembles the armor worn by St. George in LCz's early engraving *St. George and the Dragon* (fig. 4). The helmet of St. Florian, topped by a little crown, is identical to the helmet of St. George, as are the slit-puff sleeves and various ornamental details of the armor at the elbow and knee. The brushwork shorthand which represents foliage is, like that in the *Stibar Crucifixion* (fig. 27), a painted equivalent to the graphic shorthand which describes the sparsely wooded background in the engraving of the *Flight into Egypt* (fig. 7).

Master LCz's most important paintings are the *Christ on the Mount of Olives* in Darmstadt (fig. 29) and the four wings of the Strache Altarpiece, now in four different locations: *Christ before Pilate* (fig. 31) in Berlin; the *Flagellation* (fig. 33) in the Louvre, Paris; the *Bearing of the Cross* (fig. 34) in Nuremberg; and the *Crucifixion* (fig. 35), formerly in the Stenglein collection in Munich,[37] and still in private hands. It is generally assumed that the Darmstadt painting was the central panel of the Strache altarpiece, and that the other four panels were the wings. The Darmstadt painting is so closely related, both stylistically and coloristically, to the four small panels that it is more than likely that all five pictures were once physically associated. All five of the panels in this hypothetically reconstructed Strache Altarpiece are painted with the same colors. Christ is garbed in steel-blue; reds, warm yellows, and violets are also emphasized. Peculiar to Master LCz is the pale blue underpaint of the flesh tones which endows his faces with a ghostly pallor.

The four wings are on pine panels of approximately the same size, about 77 x 60 centimeters. The Darmstadt *Mount of Olives* is twice the height of the other four panels, a strong argument for its being the central panel of the Strache Altarpiece. It is highly unusual for an altarpiece of Passion subjects to have a Mount of Olives rather than a Crucifixion or Resurrection as the central panel. However, the Mount of Olives was a common subject for funerary monuments in German cemeteries, so it is possible that the Strache altarpiece, with the *Mount of Olives* in the center, was originally commissioned for a burial chapel. The fact that one of the four small panels (fig. 35) —obviously a wing and not itself a candidate for the central position—is a Crucifixion, supports the theory that the *Mount of Olives* could have been the center of the Strache Altarpiece. In at least one other instance, Master LCz created an altarpiece in which the Crucifixion was a wing rather than the central panel. There can be no doubt that the *Stibar Crucifixion* (fig. 27), because of its tall, narrow format once served as one of a pair of altarpiece wings.

The panels of the Strache Altarpiece, which were probably painted late in his career, be-

[36] A painting on the reverse depicts St. Theodota.
[37] Dr. Bernhard Saran informed me that the painting was sold in Cologne at Kunsthaus Lempertz several years ago.

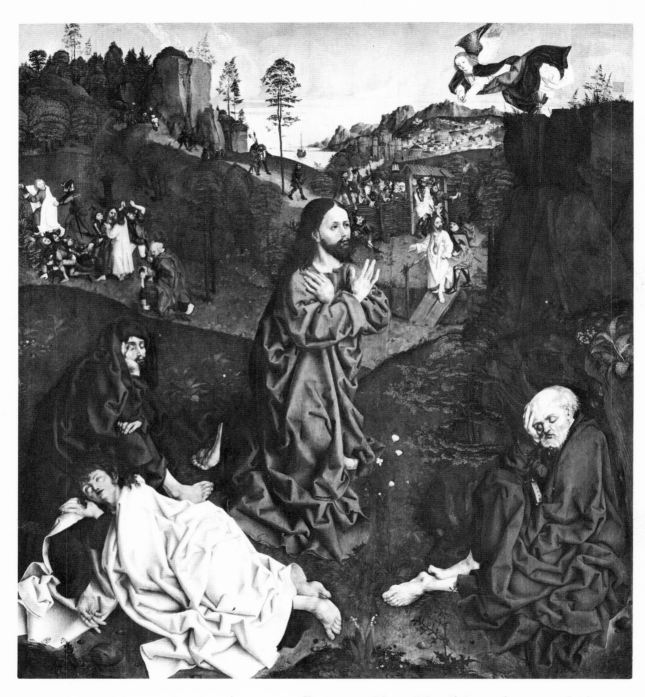

FIGURE 29 Master LCz, *Christ on the Mount of Olives,*
panel painting, Darmstadt, Hessisches Landesmuseum,
ca. 1495–1500

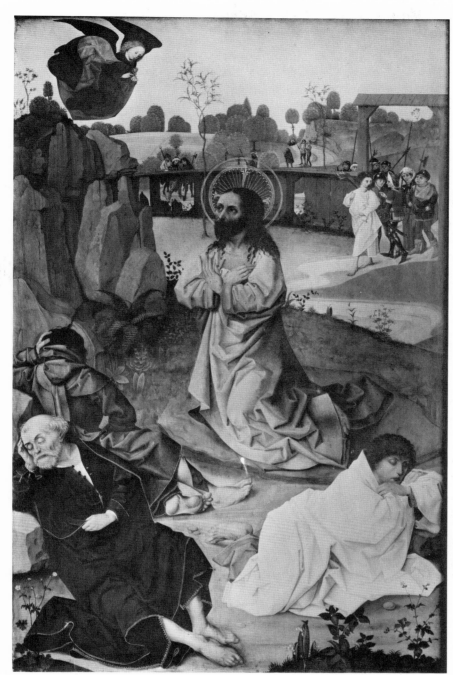

FIGURE 30 Hans Pleydenwurff,
Christ on the Mount of Olives,
panel painting,
from the Hofer altarpiece,
Munich, Alte Pinakothek,
ca. 1470

tween 1495 and 1500, still reveal Master LCz's awareness of earlier Franconian painting, especially of the Hofer Altarpiece which is now in the Alte Pinakothek, Munich. It is usually attributed to Hans Pleydenwurff and his workshop, although Wolgemuth and other Franconian painters have been mentioned as possible authors of individual wings.[38] The *Crucifixion* by LCz (fig. 35) shows a clear dependence upon the *Crucifixion* of the Hofer Altarpiece[39] in the figure type of Christ, and

in the face and hat of the centurion at the right of the cross. The *Mount of Olives* (fig. 29) of the Strache Altarpiece also derives its basic composition from the corresponding scene in the Hofer Altarpiece (fig. 30), especially in the general disposition of the figures and in the way the landscape is divided into

[38] For a summary of critical opinion on the Hofer Altarpiece see Christian A. zu Salm and Gisela Goldberg, *Alte Pinakothek München, Katalog II: Altdeutsche Malerei,* Munich, 1963, pp. 166–69.
[39] Stange, *Deutsche Malerei,* IX, pl. 81.

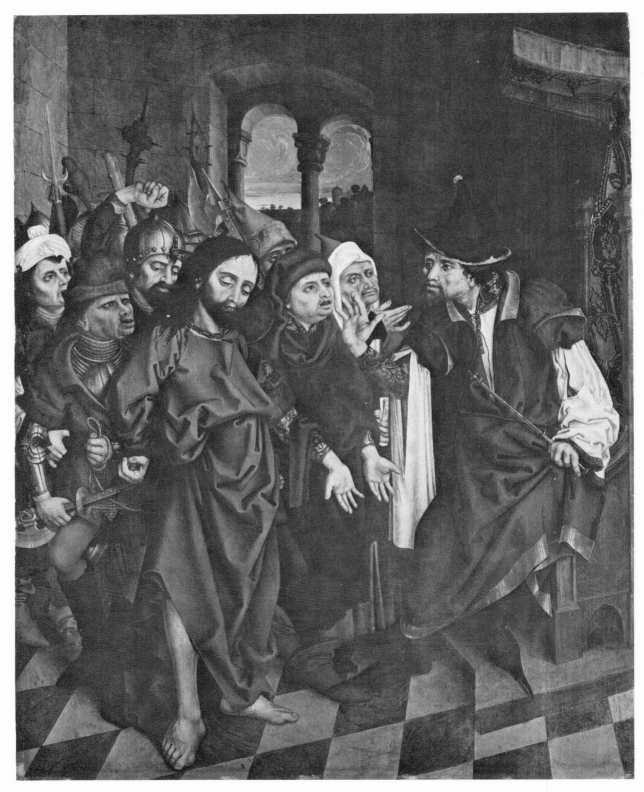

FIGURE 31 Master LCz, *Christ before Pilate,* panel painting,
Staatliche Museen, Berlin-Dahlem, ca. 1495–1500

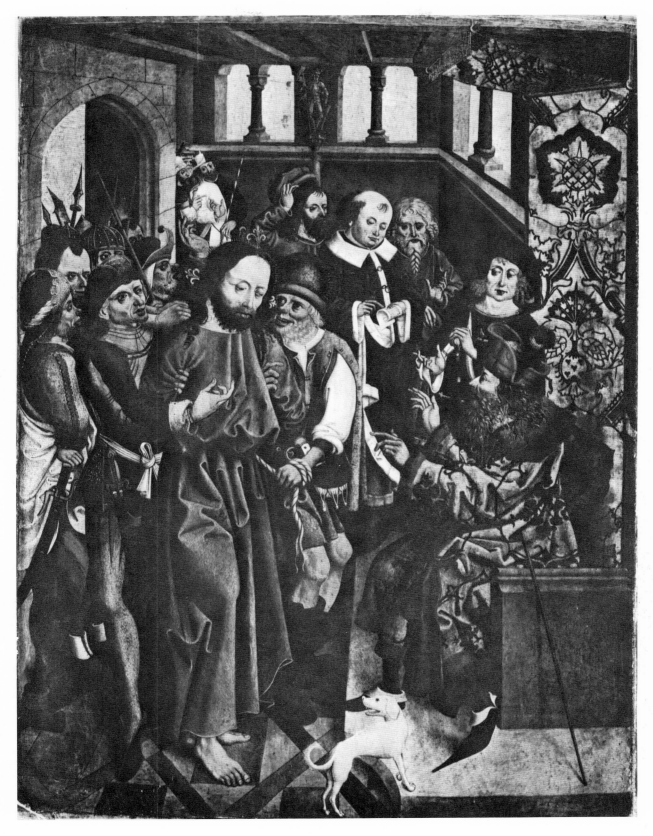

FIGURE 32 Wolfgang Katzheimer the Elder, *Christ before Pilate,*
panel painting, Nuremberg, Germanic National Museum, ca. 1480–85

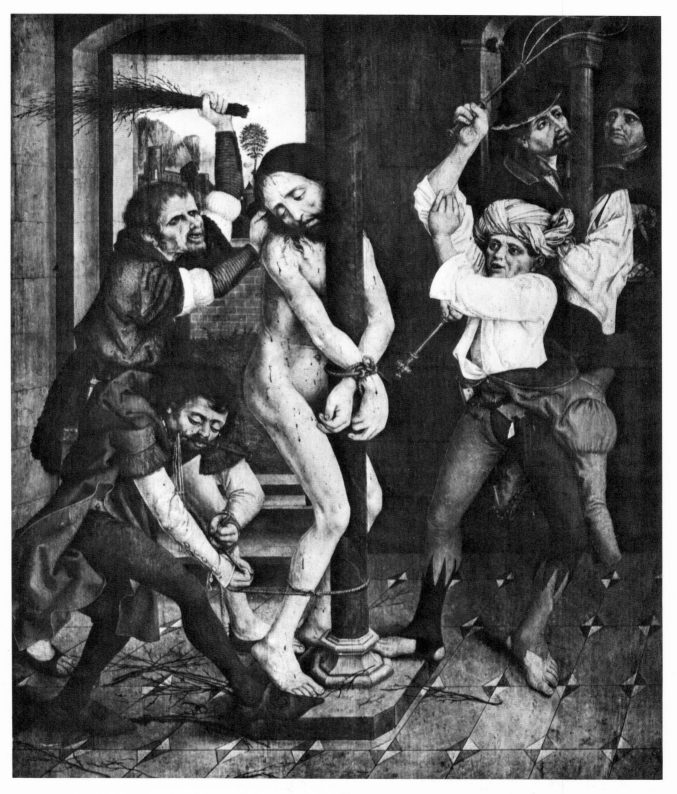

FIGURE 33 Master LCz, *Flagellation,* panel painting,
Paris, Louvre, ca. 1485–1500

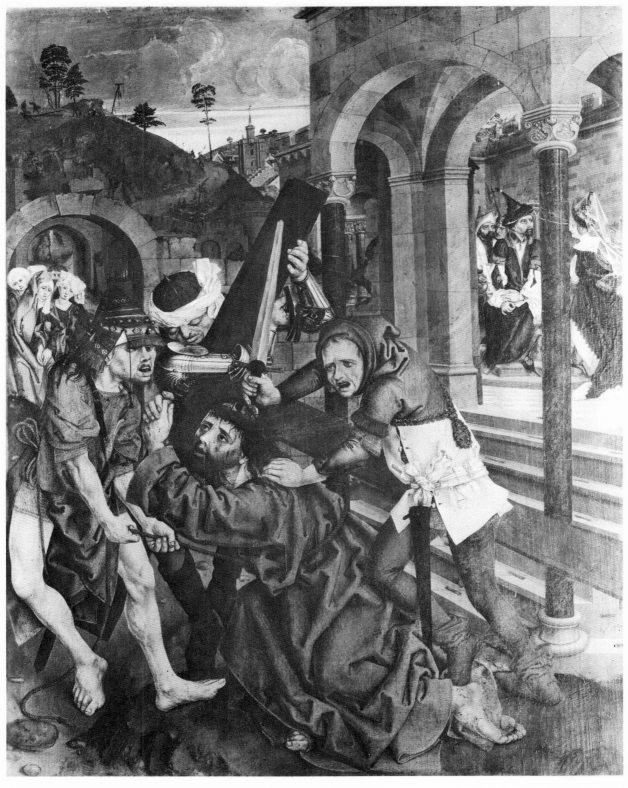

FIGURE 34 Master LCz, *Bearing of the Cross,* panel painting,
Nuremberg, Germanic National Museum, ca. 1495–1500

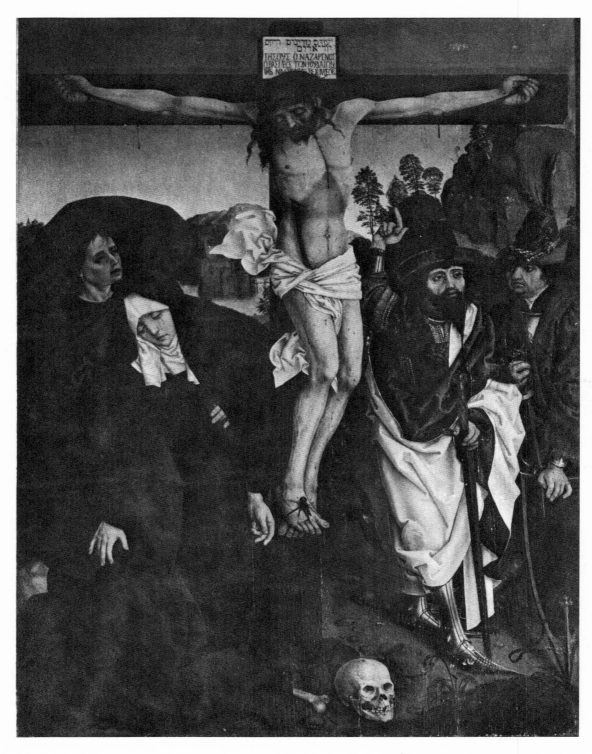

FIGURE 35 Master LCz, *Crucifixion*, panel painting,
private collection, Germany, ca. 1495–1500

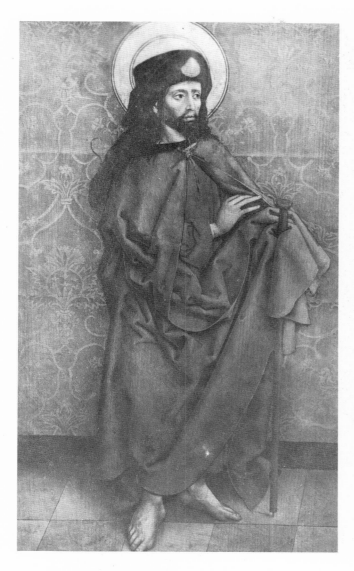

FIGURE 36 Master LCz, *St. James the Greater,*
panel painting, Sigmaringen, Museum, ca. 1485–1500

FIGURE 37 Master LCz, *St. Lawrence,* panel painting,
Darmstadt, Hessisches Landesmuseum, ca. 1495–1500

two main sections, one of which corresponds to the main foreground action and one to the activity in the background where the Roman soldiers, led by Judas, enter the garden gate. Needless to say, Pleydenwurff's conception of nature seems stylized and artificial—composed of preconceived ideas of the forms of nature—compared to LCz's lively environment convincingly observed from nature. The juxtaposition of LCz's *Mount of Olives* with Pleydenwurff's version, however, shows to what a great degree LCz's faces, figures, and drapery are

derived from traditional Franconian types and motifs.

In proposing that Master LCz was Lorenz Katzheimer we alluded to the relation of Master LCz to the workshop of Wolfgang Katzheimer of Bamberg. Anzelewsky, in supporting the connection of LCz with the Katzheimer workshop, compared the *Christ Before Pilate* of the Strache Altarpiece with the panel of the same subject from the altarpiece in the parish church of Hersbruck, attributed to Wolfgang Katzheimer the Elder.[40] We would also

[40] Anzelewsky, *Zeitschrift des deutschen Vereins,* pp. 148–49. The attribution of the Hersbruck Altarpiece to Wolfgang Katzheimer has been questioned recently by Renate Baumgärtel-Fleischmann in "Bamberger Plastik von

1470 bis 1520," *104. Bericht des Historischen Vereins für die Pflege der Geschichte des ehemaligen Fürstbistums Bamberg,* 1968, p. 36, but without convincing stylistic reasons.

FIGURE 38 Attributed by Buchner to Master LCz,
Madonna, panel painting,
Budapest, Museum of Fine Arts, ca. 1510

FIGURE 39 Attributed by Buchner to Master LCz,
St. John the Evangelist, panel painting,
Budapest, Museum of Fine Arts, ca. 1510

compare the Strache panel (fig. 31) with the
Christ Before Pilate in the Germanic National
Museum, Nuremberg, from Wolfgang Katz-
heimer's St. John Altarpiece (fig 32), usu-
ally dated between 1480 and 1485. The basic
format of the two pictures is quite simi-
lar. Pilate sits at the right on a wooden throne
beneath a baldachin of embroidered damask.

He raises his hands as if to quiet the noisy
crowd. Christ stands on a tile floor, just to the
left of center, surrounded by a group of angry
tormentors. The main difference between Wolf-
gang Katzheimer and LCz is that the latter
master is more sophisticated in his treatment of
space and convinces us that his room has vol-
ume, although he has by no means mastered

rational perspective. He reduces the number of figures and masses them in the foreground, giving them greater impact than the less cohesive crowd in Wolfgang Katzheimer's work.

Furthermore, Wolfgang Katzheimer's figures are so excessively caricatured that it is difficult for the modern viewer to take them seriously, except as grossly vulgarized symbols of human attitudes. Their main function is to emphasize, by contrast, the profound humanity of Christ. LCz's types, on the other hand, all appear to be portraits of real people whose movements and gestures are motivated by inner necessity. One feels, for example, the strong psychological connection between the man at Christ's left, who gestures so compellingly, and Pilate, who appears to signal for silence so that the accused might speak. LCz's greater realism deprives his painting to some degree of the harsh dramatic intensity of Wolfgang Katzheimer's work. Despite the differences, however, it seems clear, especially in the facial type and drapery of Christ, that Wolfgang Katzheimer's picture represents an early stage of the Bamberg style that comes to full blossom in the Strache Altarpiece.

In the 1950's, Ernst Buchner attributed four additional panel paintings to Master LCz.[41] The first two, a *St. James the Greater* in Schloss Sigmaringen (fig. 36) and a *St. Lawrence* in Darmstadt (fig. 37), were obviously both from the same altarpiece and must have flanked a central panel, now lost. The two saints, with identical opaque halos, stand on the same tile floors before identically patterned brownish-red damask backgrounds. St. James's hand disappears under his richly convoluted drapery in the same way that St. Peter's hand does in the *Entry into Jerusalem* (fig. 18). St. James also has LCz's typical tense, serious countenance, resembling the Christ of the *Temptation* (fig. 19) or the two saints of the *Sudarium* engraving of 1497 (fig. 14). Because of their relation to LCz's late prints, the *St.*

James and *St. Lawrence* were dated by Buchner in the late 1490's.

Buchner also ascribes to LCz two other panels, busts of the Virgin and of St. John (figs. 38, 39) in the Museum of Fine Arts, Budapest, and places them at the very end of the artist's career.[42] The Madonna's face and hood (fig. 38) are very like those of the Madonna in the engraved *Flight into Egypt* (fig. 7), while her hands closely resemble those of Christ in the Darmstadt *Mount of Olives* (fig. 29). The unique use of colors (deep blue and pure red, warm green and carmine pink), as well as the expressive drawing of the hands, further supports the attribution to Master LCz.[43] According to Buchner, these two paintings show the influence of Dürer to a greater degree than any other work by LCz; he feels that this accounts for some fairly obvious dissimilarities between these and LCz's other paintings. We are hesitant to accept the attribution as secure. It seems possible that the Budapest paintings were created by a Bamberg artist who was active as late as 1515 or 1520 and was influenced both by Master LCz's pictures and by Dürer. It is difficult, however, to agree with Stange's attributions of these pictures to Jakob Elsner.[44] They do not conform at all to the style of Elsner's accepted portraits, in which the sitters typically have large, blunt features.[45]

DRAWINGS

Only two drawings have ever been attributed to Master LCz. In 1924, Martin Weinberger attributed to him a copy after Schongauer's *Miller* engraving (Lehrs 88).[46] This drawing seems to have little to do with Master LCz, however, and Weinberger adduces no compelling evidence to support his attribution.

A drawing with a much stronger claim to LCz's authorship is the little *Gothic Ornament*

[41] Buchner, *Festgabe, passim;* Buchner, *Zeitschrift für Kunst,* p. 322.

[42] Buchner, *Festgabe,* p. 87.

[43] I have not seen the Budapest pictures. The colors were described by Buchner. A. Pigler, in *Katalog der Galerie Alter Meister,* Museum der bildenden Künste, Budapest, I, 1968, nos. 843–844, p. 210–11, accepts Stange's attribution

to Elsner. See also footnote 44.

[44] Stange, *Deutsche Malerei,* IX, p. 85, note 14.

[45] See Ernst Buchner, *Das deutsche Bildnis der Spätgotik und der frühen Dürerzeit,* Berlin 1953, pls. 153–160.

[46] Weinberger, *Festschrift Wölfflin,* p. 178. The drawing is reproduced in Gutekunst auction catalogue 76 (Peltzer sale, 1914), as no. 378, there attributed to Barthel Schön.

with a Lady and a Parrot in the National Gallery of Art, Rosenwald Collection (fig. 40). The drawing was attributed to LCz for the first time in the catalogue of the L. V. Randall sale at Sotheby's (London, May 10, 1961, no. 13), and was again published as LCz's work by the present author in 1966.[47] My arguments for

pointed at the bottom, and the facial features, especially the beady eyes set between carefully drawn lids, are almost identical, as are the gestures of the arms, which seem to be uncomfortably hinged at the elbow like those of store-window mannequins.

FIGURE 40 Master LCz, *Gothic Ornament with a Lady and a Parrot,* pen drawing, National Gallery of Art, Rosenwald Collection, ca. 1495

attributing the drawing to LCz can be briefly summarized. First of all, the drawing is closely related to two of the engravings, the *Lady and Servant in a Meadow* (fig. 2) and the *Maiden Taming the Unicorn* (fig. 9). The woman in the Rosenwald drawing is almost an exact counterpart of the elegant lady of the *Lady and Servant,* in proportion, posture, and attitude. Both figures stand rather stiffly in the front plane of a very shallow space, and turn slightly out of the profile view to be seen from a three-quarters angle. In both figures the shape of the head, with a flat brow and a skull

The Rosenwald drawing is comparable to the *Maiden Taming the Unicorn* (fig. 9) in the way the figure asserts itself in the midst of complex foliage and vine patterns. In addition, there are certain parallel traits of draftsmanship, such as the angular outlines of the sleeves and the way drapery is bunched at the crook of the arm. The pen work in the drawing, with its short sketchy lines, approximates most closely the burin style of the *Madonna Nursing the Child* (fig. 12), characterized by little flecks and strokes. This engraving is also analogous to the drawing in the treatment of drapery folds. The drapery, which is sumptuous and richly convoluted in the two works, is very

[47] Alan Shestack, "A Drawing by Master LCz," *Burlington Magazine,* CVIII (no. 760), 1966, pp. 366–69.

similar in character, spreading out in such a way as to firmly anchor the figure to the ground. Finally, the figures in both the print and the drawing are tenderly conceived and possess a pleasant, naïve charm, a quality not found in LCz's work after the mid-1490's.

Thus, on the basis of the similarities of the drawing to the early *Lady and Servant* and to the *Madonna and Unicorn* of 1492, as well as its relation to the *Madonna Nursing the Child,* which we date in the mid-1490's, we can propose an approximate date for the drawing of about 1495—probably just before the creation of LCz's masterpieces, the Strache Altarpiece and the engraving of the *Temptation of Christ.*

Master WB

OF all the works attributed to Master WB, only two of the engravings bear the artist's monogram: the initials "W" and "B" separated by a symbol which appears to be a staff or cross with an entwined "S" in reverse (figs. 42, 44). Daniel Burckhardt suggested that the symbol was a family housemark commonly found in coats of arms—and sometimes carved on monuments and old houses—in the region of Staufen between Basel and Freiburg-im-Breisgau, and that it evolved from an intertwined "S" and "T" which stood for the first two letters of "Staufen."[1] Lehrs, who thought of WB as an Upper Rhenish master, was quick to accept Burckhardt's suggestion.[2] Others, notably Leo Baer,[3] who proposed that the four WB prints were late works by the Master of the Housebook, argued that the monogram was a publisher's symbol and referred to it as "the monogram WB with the serpent staff (*Schlangenstab*)." Neither of these explanations is fully satisfying. The reversed "S" does appear to be a capital letter rather than a snake, but Burckhardt's suggestion that the vertical member is a corrupted "T" is difficult to accept without more persuasive evidence. Our present knowledge that WB was active in the Middle Rhine and Lower Main region (*not* in the Upper Rhine valley) casts additional doubts on Burckhardt's theory.

ENGRAVINGS

There are only four known engravings by Master WB. Although the WB monogram appears on but two of these, it is clear that the four prints were conceived as two pairs. The artist thus needed to monogram only one print

in each pair. It is possible, however, that the *Young Woman with the Headdress* (fig. 45), which survives in only one impression, in Berlin, might also have been monogrammed. The sheet on which it is printed is twenty millimeters shorter than its companion piece (fig. 44) and may have been cropped at the bottom, resulting in the loss of both the window sill and the monogram.

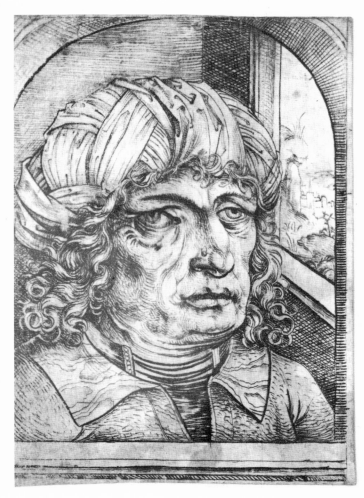

FIGURE 41 Master WB, *Old Man in a Turban,* engraving, ca. 1485–87

[1] Lehrs, *LCz und WB,* p .10.
[2] Lehrs, *Geschichte und Kritischer Katalog,* VI, pp. 344–45.

[3] Leo Baer, "Weitere Beiträge zur Chronologie und Lokalisierung der Werke des Hausbuchmeisters," *Monatshefte für Kunstwissenschaft,* III, 1910, pp. 412–13.

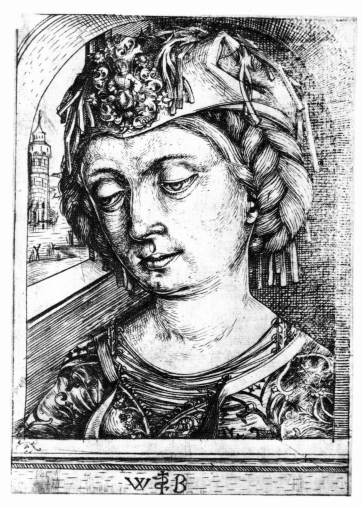

FIGURE 42 Master WB, *Lady with a Jeweled Cap,*
engraving, ca. 1485–87

FIGURE 43 Master of the Housebook,
Heads of Christ and the Virgin, drypoint,
ca. 1485–90 (detail)

In the first pair of WB engravings (figs.
41, 42) the bust-length figures of a male and
female appear under round-arch openings,
with interior views of uncomfortably small
rooms behind them. Each room has a window
through which we glimpse a landscape vista.
In the *Old Man in a Turban* (fig. 41), the
massive, chunky head dominates the space and
threatens to break out of the very narrow con-
fines of the room. The broad, angular face,
the unkempt curly locks, the sad eyes with
bulging lids and pouchy crow's-feet, and the
thick lips and large lumpy nose create a
rough, ungroomed appearance. This effect is
heightened by the uninhibited sketchy model-
ing of the cheek and eye socket.

The face of his female counterpart, the
Lady with a Jeweled Cap (fig. 42), is by
comparison much more firmly structured and

unified. Although the lady casts her glance
downward and appears pensive, her face shows
none of the traces of old age seen in the
companion engraving. It is less insistently mod-
eled and its smooth, rounded surfaces form a
pleasing contrast to the elegant hairdo, jeweled
cap, and brocade dress. The facial features,
especially the bulging eyes and eyelids, are
carefully articulated. The head almost touches
the margin line at the top edge of the picture
and seems, like the head of the *Man in a
Turban,* to be on the verge of breaking out of
the picture's confines. Both figures are hemmed
in by the minimal space behind them and by
the window sills against which they lean.

The tiny landscape view at the left in the
Lady with a Jeweled Cap—a castle tower sur-
rounded by water—is handled with great spon-
taneity, as though the artist were using a pen
or drypoint rather than a burin. Both the in-
formal linear quality of the burin lines and the
character of the building itself recall landscape
backgrounds in drypoints by the Master of the
Housebook, such as those in the *Crucifixion*
(Lehrs 14) or the *Holy Family by the Rose-
bush* (Lehrs 27). The face of WB's lady also
calls to mind a familiar Housebook Master
type, like the Madonna in the *Heads of
Christ and the Virgin* (fig. 43). There can be

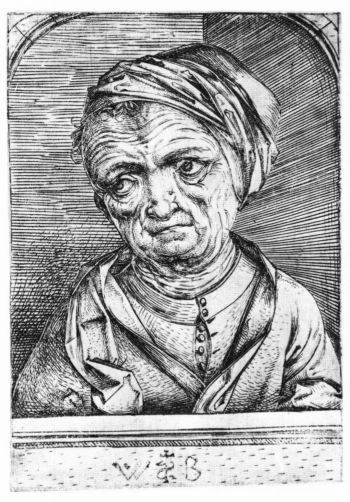

FIGURE 44 Master WB, *Old Man,* engraving,
ca. 1485–87

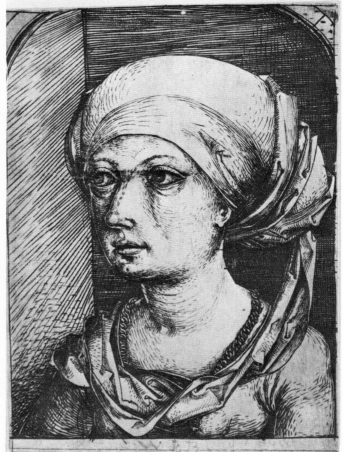

FIGURE 45 Master WB, *Young Woman with
the Headdress,* engraving, ca. 1485–87

no doubt that the Housebook Master was a
major source of inspiration for Master WB.

In the second pair of WB engravings, the
Old Man and the *Young Woman with the
Headdress* (figs. 44, 45), the figures are
slightly smaller in proportion to the space and
therefore not as cramped. Once again the fig-
ures are set in the corners of sparse interiors,
but no windows interrupt the parallel model-
ing which serves as the only backdrop. As in
the first pair, an ugly elderly male with a
deeply wrinkled face is juxtaposed with a
younger, smooth-skinned female. The old man
tilts his head pathetically, as if he were pro-
foundly depressed or melancholic. His large
eyes stare out mournfully and his lips are

pressed together tightly as if he were resigned
to his age, his fate, or his physical deteriora-
tion. The furrowed, care-worn face is almost a
physical map of a lifetime of hardships. No
other fifteenth-century German artist with the
exception of the Housebook Master, could im-
bue a face with so much character and make it
so evocative of physical and psychological
conditions.

The female counterpart (fig. 45) is almost
the exact opposite of the wizened old man.
Her young face is smooth and unblemished.
Unlike the man, she seems to totally lack per-
sonality. Her bulbous goggle-eyes, even more
emphatic than those of the first lady, stare life-
lessly forward, as if she were in a trance. It
seems as though the engraver took great pleas-
ure in reconstructing the shriveled skin and
sagging flesh of the elderly faces, which fasci-
nated him because of their great expressive-

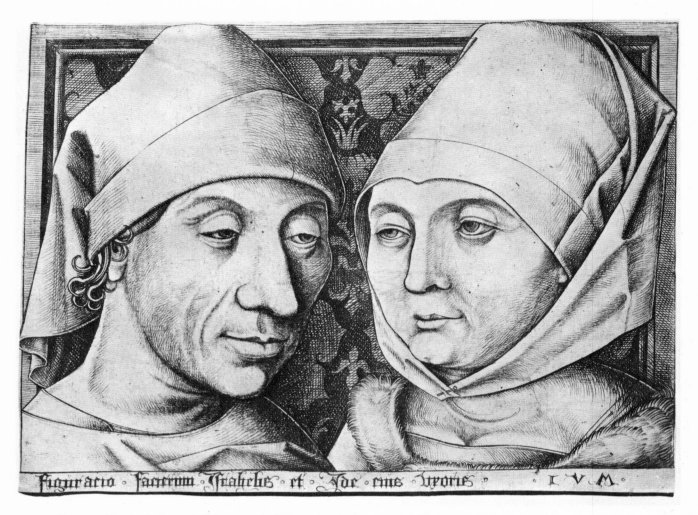

FIGURE 46 Israhel van Meckenem, *Self-Portrait of the Artist and His Wife,*
engraving, ca. 1490

ness, but that he was uninspired by the smooth, taut skin and sharply defined features of younger faces.

Lehrs refers to the four WB engravings as "portraits," but it seems more plausible that they are not likenesses, strictly speaking, but rather character-types of old age and youth, only superficially related to actual people studied by the artist.[4] Certainly the great variance in age between the man and woman in each pair argues against their being portraits of married couples. The paired prints seem clearly different in conception from pictures

such as Israhel van Meckenem's famous engraved portrait of himself and his wife (fig. 46). Buchner suggested that WB created in his prints a personal interpretation of the ancient theme of the old man and the young woman (*Ungleiches Liebespaar*), common in late medieval poetry and art, especially in Germany. Moralizing pictures of this sort appear in the work of Hans Baldung Grien and Lucas Cranach, and very frequently in the engravings of Dürer's predecessors. Usually the man and woman are shown together in one scene (fig. 47); the old man makes a fool of himself as he makes advances toward the young lady, who is interested only in the money in his purse. The great contrast in form and feeling between the man and the woman in WB's pairs seems obviously intended to establish this or a similar allegorical meaning.

[4] Lehrs, in *Geschichte und Kritischer Katalog,* VI, p. 344, felt that they were WB's version of the so-called Oriental types of Schongauer. Buchner, in *Münchener Jahrbuch,* p. 249, found the female types to be Semitic in character and speculated that they were inspired by the large Jewish population in the Middle Rhine region in the 1480's.

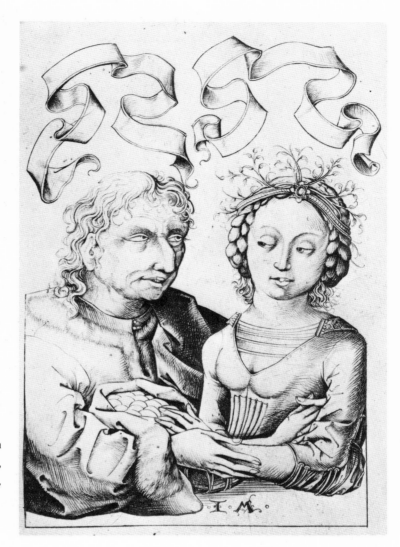

FIGURE 47 Israhel van Meckenem
(after the Master of the Housebook),
Foolish Old Man and Young Girl,
engraving, ca. 1480–90

PORTRAITS

In 1927, Ernst Buchner published a substantial group of paintings which he ascribed to Master WB on the basis of stylistic affinities with the four engravings.[5] Although a few of Buchner's attributions have not stood the test of time,[6] the majority form the corpus of pictures now attributed to Master WB.

A pair of painted portraits in the Städel Institute in Frankfurt (figs. 48, 49) are particu-

larly close in style to the four engravings. The portraits are of a well-to-do burgher, probably a merchant, and his wife. They are dressed in their best finery and assume formal and slightly stilted poses. The man wears a fur cap and fur-lined cape and holds a rosary, indications of both his affluence and his piety. Through an open window we see a rocky landscape. The woman sits before an identical gold damask background, wearing an elaborate, bejeweled coif and gingerly holding a pearl cross on a chain. Through her window we view a river valley with a castle.[7]

[5] See p. 12, footnote 9.
[6] The portrait reproduced as figure 5 by Buchner in *Münchener Jahrbuch,* p. 234, is now unanimously attributed to Michael Wolgemuth. See W. Wenke in *Anzeiger des Germanischen Nationalmuseums,* XXXIII, 1932, p. 61.

[7] A layer of grey-green overpaint was removed from the backgrounds of the two paintings in the early 1930's, revealing the charming landscape views. See Alfred Wolters, "Anmerkungen zu einigen Röntgenaufnahmen nach Gemälden des Städelschen Kunstinstituts," *Städel Jahrbuch,* VII–VIII, 1932, pp. 233–34, pls. 191–194.

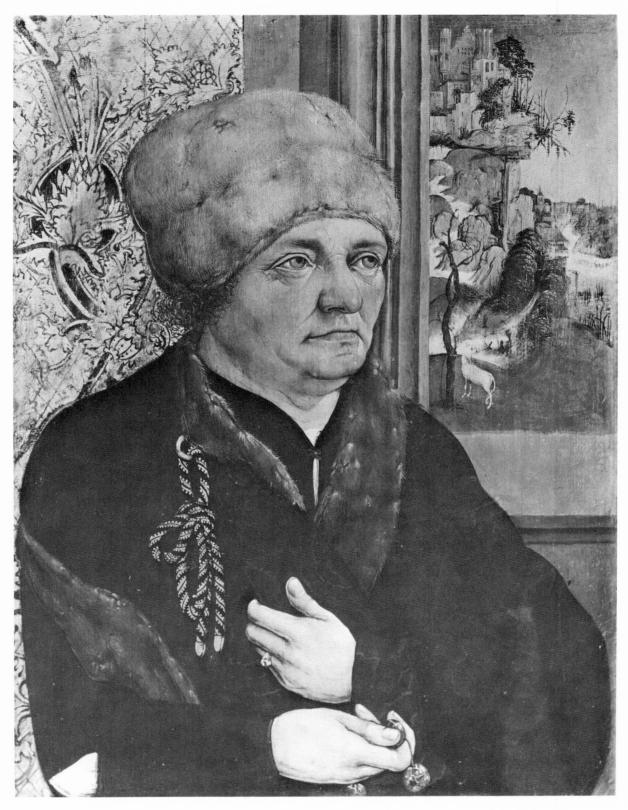

FIGURE 48 Master WB, *Portrait of a Man,* panel painting,
Frankfurt, Städel-Institut, ca. 1490

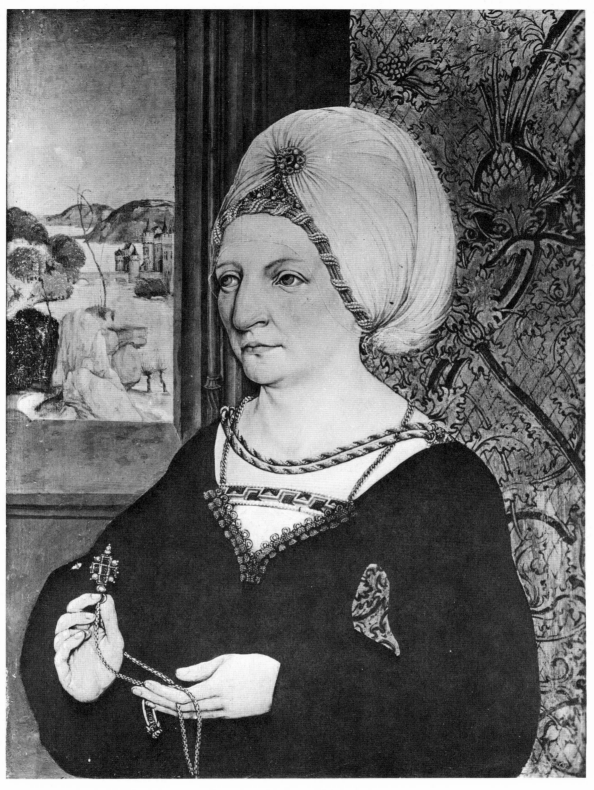

FIGURE 49 Master WB, *Portrait of a Woman*, panel painting,
Frankfurt, Städel-Institut, ca. 1490

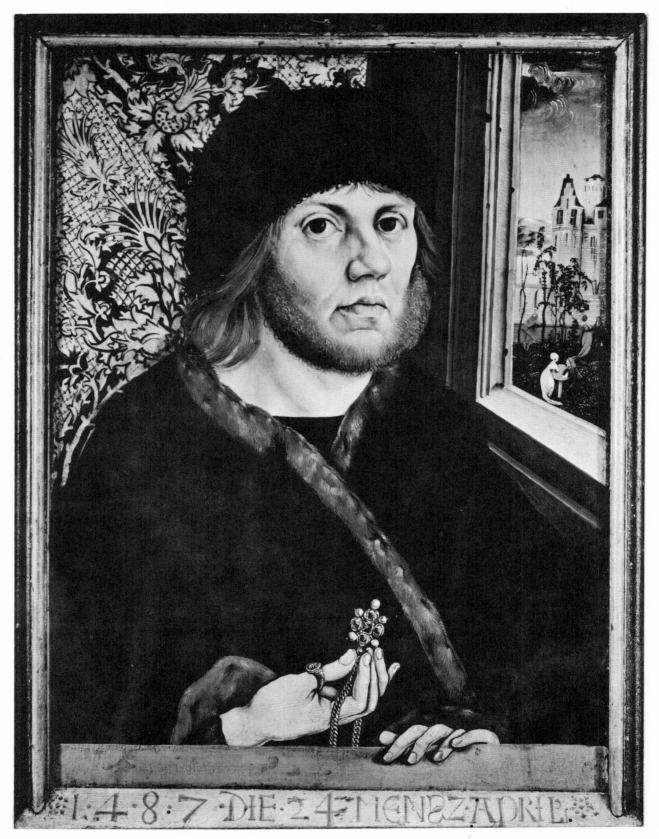

FIGURE 50 Master WB, *Portrait of a Man,* panel painting,
Lugano, Thyssen Collection, 1487

The similarity of the facial topography in these two paintings to that in the WB engravings is unmistakable, especially in the way the features are structured and related to the mass of the head. Although the man in the Frankfurt painting does not have the almost caricatured appearance of the engraved *Man in a Turban* (fig. 41), the nose, mouth, and chin of the two are similar in shape and size, and the eyes are set under the brows in an identical manner. The lady in the Frankfurt portrait is so similar to the women in WB's two female engravings (figs. 42, 45) that one feels they could all be members of the same family. Her prominent nose is more hawk-like than the noses of the other two, but she has similarly accented features. The definition of her eyes and brows is very close to that of the *Young Woman with the Headdress* (fig. 45), and her nostril, lips, and partially cleft chin closely resemble those of the *Lady with a Jeweled Cap* (fig. 42). Although WB was a penetrating observer of the human face, he was also a stylist who developed an ideal female type which recurs time and again in his work. Even his portraits from life were transformed to conform to this type, accounting for the resemblance between the Frankfurt female portrait and the character types in the engravings.

A male portrait in the Thyssen Collection, Lugano (fig. 50), dated 24 April 1487, is also clearly from Master WB's hand, and was probably done about the same time as the four engravings. The sitter's large round eyes and intent gaze are a hallmark of WB's work. Furthermore, the structure of the face—eyebrows, nose, and lips—is very like that of the male Frankfurt portrait. The brushwork in the fur which lines the man's garment is also similar to that in the Frankfurt portrait. Finally, the Lugano sitter holds a pearl cross which is almost identical to the one held by the lady in Frankfurt (fig. 49), and the knuckles and fingernails in both portraits have the same small, painted highlights.

In the two Frankfurt paintings (figs. 48, 49), the sitters are placed in front of a flat wall, half of which is occupied by a damask hanging and half by a landscape vista seen through a rectangular window opening. This motif is Netherlandish, and it appears in Germany for the first time in these two pictures. It was taken up by Dürer in 1499 [8] and thereafter became the standard portrait format in Germany. The idea may have been transmitted to Dürer through a Rhenish intermediary such as Master WB, rather than from a direct Netherlandish influence.

Master WB appears to have understood the advantages of placing all background elements on a single plane, and in the Frankfurt portraits he used this simple format as an aid in focusing attention on the figures. He also garbed them in dark colors, so that they are silhouetted against the light background. In the Lugano painting (fig. 50), the artist used a more awkward arrangement of figure and space, emphasizing the corner of the room and a narrow, foreshortened window. This schema, which tends to cramp the figure, is also found in the engravings (figs. 41, 42). On this basis, Buchner dated the engravings about the time of the Lugano painting, 1485 to 1487, and he dated the two Frankfurt portraits—with their more evolved and more effective arrangement —slightly later, about 1490.[9]

Another portrait which must surely be included as part of Master WB's *oeuvre* is the *Woman in a Coif* (fig. 51), in the Germanic National Museum, Nuremberg, attributed by Stange to the Master of the Salemer Altarpiece.[10] The half-length figure is firmly set in a totally abstract space. Her face is a slightly milder version of the Frankfurt female portrait, though it has the same sharp features, especially the hooked nose. Her facial type is similar also to that of the engraved *Young Woman with the Headdress* (fig. 45). They both have deeply set eyes fixed in a steady gaze, and long necks accented by circular creases. In both of these works the long kerchief-like end

[8] The Netherlandish motif appears in Dürer's portraits of Hans and Felizitas Tucher of 1499 in Weimar. The scheme was also adopted by Bernhard Strigel in his portraits of Emperor Maximilian and his family.

[9] Buchner, *Münchener Jahrbuch*, pp. 235, 238.

[10] Stange, *Deutsche Malerei*, VII, p. 50.

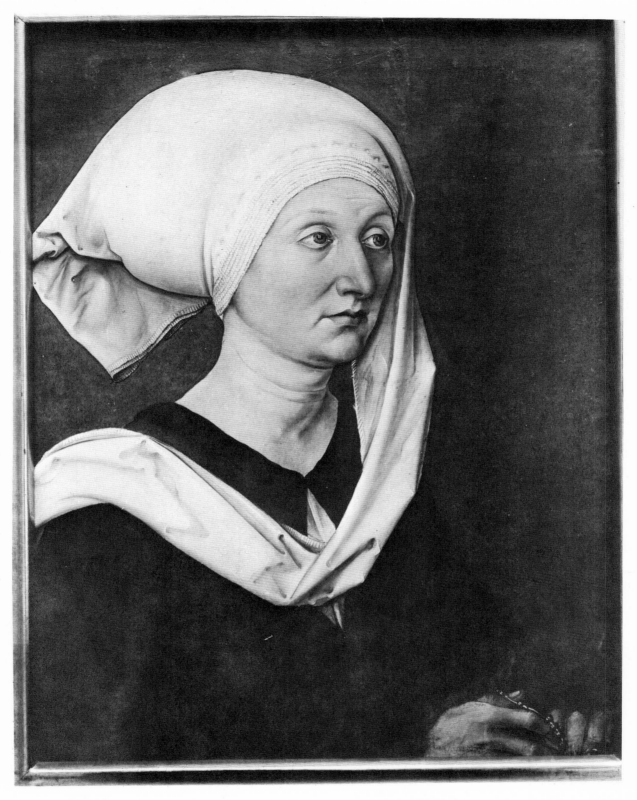

FIGURE 51 Master WB, *Portrait of a Woman in a Coif,*
Nuremberg, Germanic National Museum, ca. 1490–95

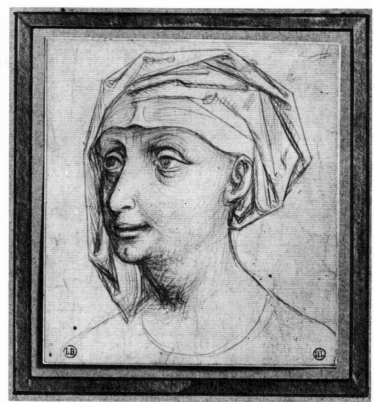

FIGURE 52 Master WB, *Portrait of a Woman,* silverpoint drawing, Bayonne, Musée Bonnat, ca. 1485–87

of the headgear hangs down, swinging across the chest and over the shoulder. In the engraving it functions primarily as a decorative accessory, while in the painting it is more subtly employed to frame, isolate, and attract attention to the face.

If we assume that, as WB's style developed, he was able to achieve increased lucidity and a greater monumental quality, it can be argued that the Lugano picture of 1487 (fig. 50) is the earliest of the group, followed by the pair in Frankfurt (figs. 48, 49), and then the portrait in Nuremberg (fig. 51).[11] The composition of this final portrait most nearly approaches the cogency and simplicity of true Renaissance style, anticipating the epoch of Dürer and especially Dürer's portrait of Elisabeth Tucher of 1499 in the museum in Kassel.

In the Musée Bonnat, Bayonne, there is a small silverpoint drawing of a woman which can also be attributed to Master WB (fig. 52). The conception of the face is very like that found in the paintings and engravings discussed so far. The face is particularly similar to that of the engraved *Young Woman with the Headdress* (fig. 45), especially in the construction of the eyes and mouth. The drawing appears to be a study from life, although, as usual, WB has adjusted nature to fit a preconceived ideal. The nose and the slightly dimpled chin, for example, are from his standard repertoire. The silverpoint lines are dry and hesitant, and the artist has reworked some areas, especially the contours of the neck and cheek, as he sought to adequately suggest a three-dimensional form. The tentative character of the line suggests that the drawing is an early work, perhaps pre-dating WB's four prints.

[11] A portrait in the historical museum of Frankfurt attributed to Master WB by Stange (*Deutsche Malerei,* VII, pl. 256) is in my opinion not by the artist, although it is Middle Rhenish, ca. 1470–80. Two other male portraits once given to WB (see *Pantheon,* VI, 1930, p. 343) are now usually called "Middle Rhenish, ca. 1490." For additional information on WB's accepted portraits see Ernst Buchner, *Das deutsche Bildnis der Spätgotik und der frühen Dürerzeit,* Berlin, 1953, pp. 46–50, pls. 31, 33–34, 37. Buchner has hypothesized that Master WB painted a portrait, now lost, of Rudolf Agricola, which is known through a nineteenth-century engraving by an artist named Kaergling and reproduced in Buchner, *Das deutsche Bildnis,* pl. 39. Buchner believes that the engraving was based directly on WB's original panel. The face of Agricola compares closely to the male portrait in Frankfurt (fig. 48), and the gestures of his hands recall those of the female portrait in Frankfurt (fig. 49). It is not inconceivable that Agricola could have sat for a portrait by Master WB. In 1483, Agricola came to Heidelberg and divided his time between that city and Worms, where he lectured and pursued his studies. He died in 1485, and was interred in the Minoritenkirche in Heidelberg.

In addition to his portraits, Master WB painted as least two altarpieces. From the first one, only two panels survive. They are both tall, narrow altar wings with scenes from the childhood of Christ. One of them, a *Nativity,* is in a private collection in Munich.[12] The other, a *Presentation in the Temple,*[13] is in the Bavarian state painting collection (fig. 53). As in the WB engravings, the elderly male faces in the *Presentation* are more effectively characterized than the female ones, though all the figures have prominent noses and large eyes. The artist's emphasis on wrinkles around the eyes gives his figures an aged and venerable appearance, particularly suitable to the solemn nature of biblical subjects. The face of Mary, at the right of the altar (see fig. 53a), is very like the face of the engraved *Young Woman with a Headdress* (fig. 45). The beardless figure next to Mary is a reversed variant of the *Old Man* engraving (fig. 53b). These two heads (figs. 53a–b) are so similar, in fact, that the comparison secures the attribution of the *Presentation* painting to Master WB.

Another characteristic of WB's paintings is the use of little daubs of paint for highlights on hands and faces, giving skin surfaces a glossy texture. This quality, present to some extent in the Frankfurt portraits, is a major characteristic of the master's later paintings.

Rieffel was the first to see a stylistic connection between the WB portraits in Frankfurt (figs. 48, 49) and the eight panels of the Mainz Sebastian Legend (figs. 54–61), now in the Diocesan Museum in Mainz.[14] There is no question that these paintings are by Master WB. The facial types, with hooked noses and bulging eyes, as well as several peculiarities of draftsmanship, relate the figures in the Sebastian panels not only to the WB portrait

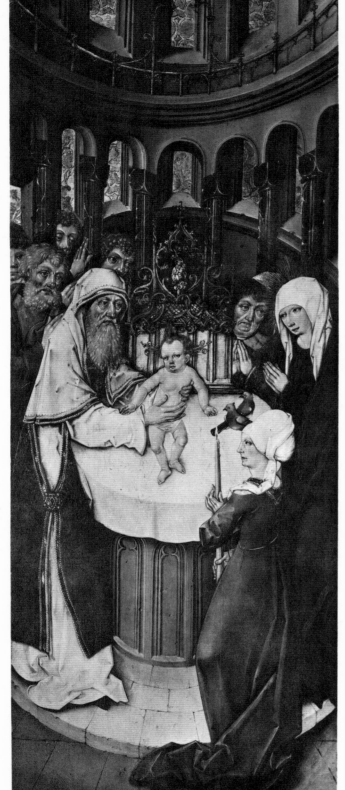

FIGURE 53 Master WB, *Presentation in the Temple,* panel painting, Aschaffenburg, Gallery, ca. 1485

[12] Reproduced by Buchner in *Münchener Jahrbuch,* fig. 10, and by Stange in *Deutsche Malerei,* VII, pl. 247. The painting is on a spruce panel and measures 141 x 53.7 cm.
[13] This painting is also on spruce, and measures 141 x 53.5 cm. The painting is presently in Aschaffenburg. See *Bayerische Staatsgemäldesammlungen, Galerie Aschaffenburg Katalog,* Munich, 1964, p. 113.
[14] Franz Rieffel, "Die Freiherrlich von Holzhausensche Gemäldesammlung in der Städelsche Galerie," *Monatshefte für Kunstwissenschaft,* IV, 1911, p. 345.

paintings, but also to the four engravings. Four of the panels have gothic vine ornaments applied in gold leaf to the upper corners, while four are undecorated. Since the panels with gold-leaf decoration and those without do not fall into a pattern when organized in chronological sequence, a logical reconstruction is difficult. The eight surviving panels probably represent only a fraction of the original altarpiece, since many of the well-known episodes in Sebastian's life are missing. The question of grouping is complicated by the fact that the Sebastian legend is entirely apocryphal and was subject to many variations, and hence there is no standard iconography.

The eight paintings, which are of almost identical size, about 85 x 66 centimeters, represent scenes preceding and following Sebastian's famous ordeal; the climactic scene— Sebastian pierced by arrows—is conspicuously absent. It is usually assumed that a large painting of the famous martyrdom, now lost, served as the central panel of the Mainz altarpiece, and that the eight surviving panels (and probably some others that are no longer extant) were grouped around it.

Two of the scenes show St. Sebastian prior to his martyrdom, either consoling Christian victims of paganism (fig. 54) or spreading the Gospel (fig. 55). Three scenes deal with Sebastian in conflict with the Emperors Diocletian and Maximian. In the first (fig. 56), Sebastian debates with the two emperors and expounds the tenets of Christianity. The silver-bearded Diocletian appears to be explaining Sebastian's argument to Maximian. In the next scene (fig. 57), Sebastian has obviously strained the patience of the two emperors and has been arrested and sentenced to death. The third panel (fig. 58) shows Sebastian some time later, after he has survived the rain of arrows and has been nursed back to health. He stands on the palace steps and appears to be counting off on his fingers the many sins of the two emperors. To be sure that Sebastian did not escape death again, the emperors had him beaten with cudgels (fig. 59) and then had his body dumped into the sewers (fig. 60) so that it would not be found. However, friends of

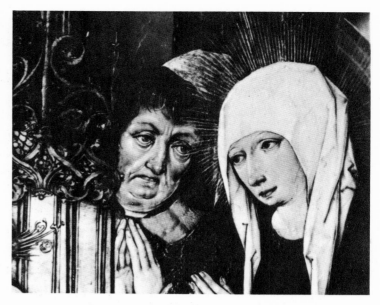

FIGURE 53a Master WB, *Presentation in the Temple,* panel painting, Aschaffenburg, Gallery, ca. 1485 (detail)

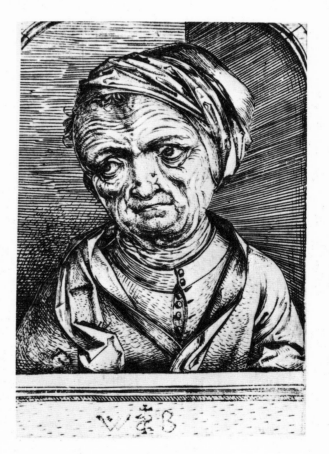

FIGURE 53b Master WB, *Old Man,* engraving, ca. 1485–87

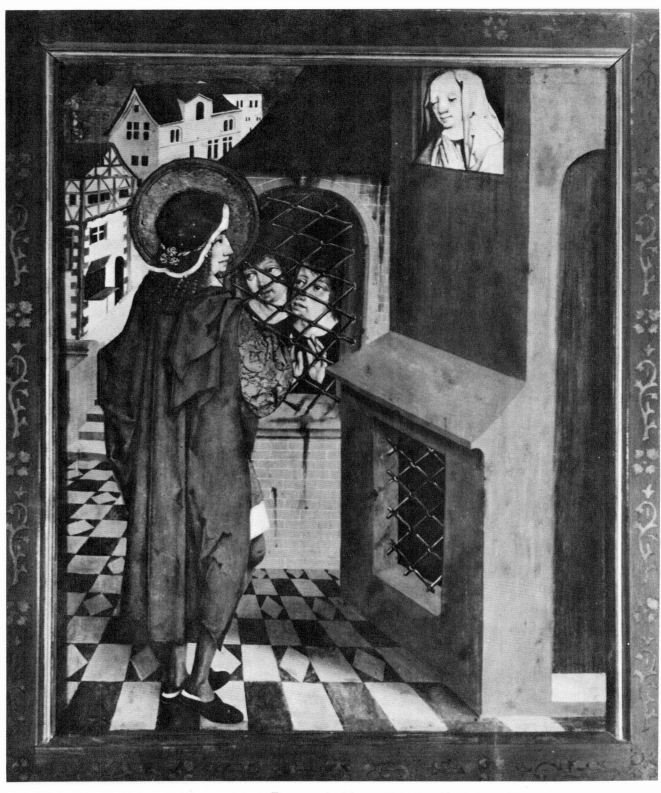

FIGURE 54 Master WB, *St. Sebastian at the Jail,* panel painting,
Mainz, Diocesan Museum, ca. 1490

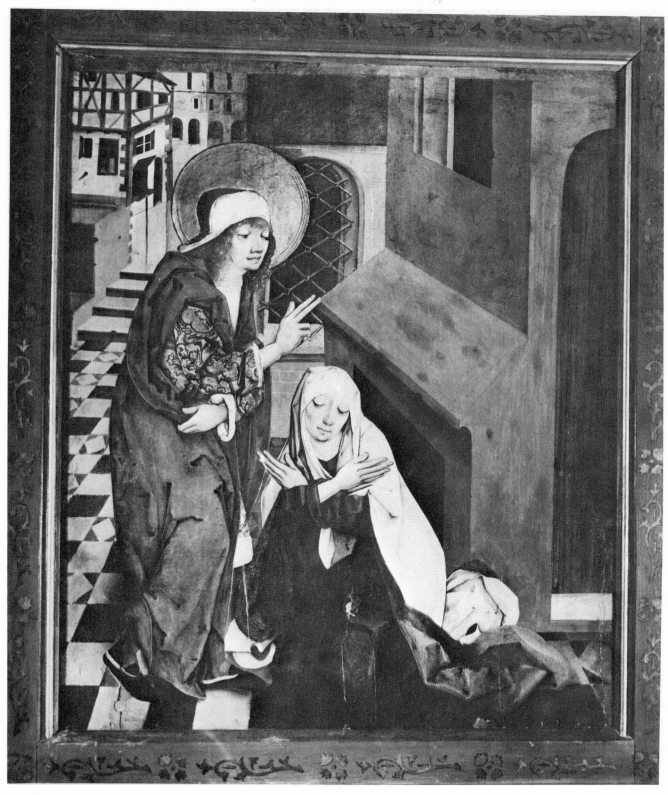

FIGURE 55 Master WB, *St. Sebastian and Zoe,* panel painting,
Mainz, Diocesan Museum, ca. 1490

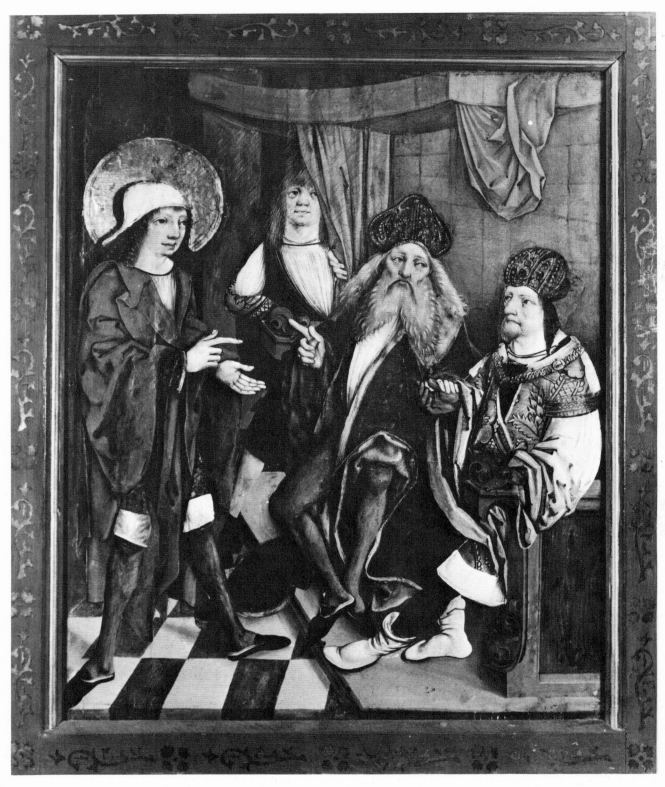

FIGURE 56 Master WB, *St. Sebastian with the Emperors,* panel painting,
Mainz, Diocesan Museum, ca. 1490

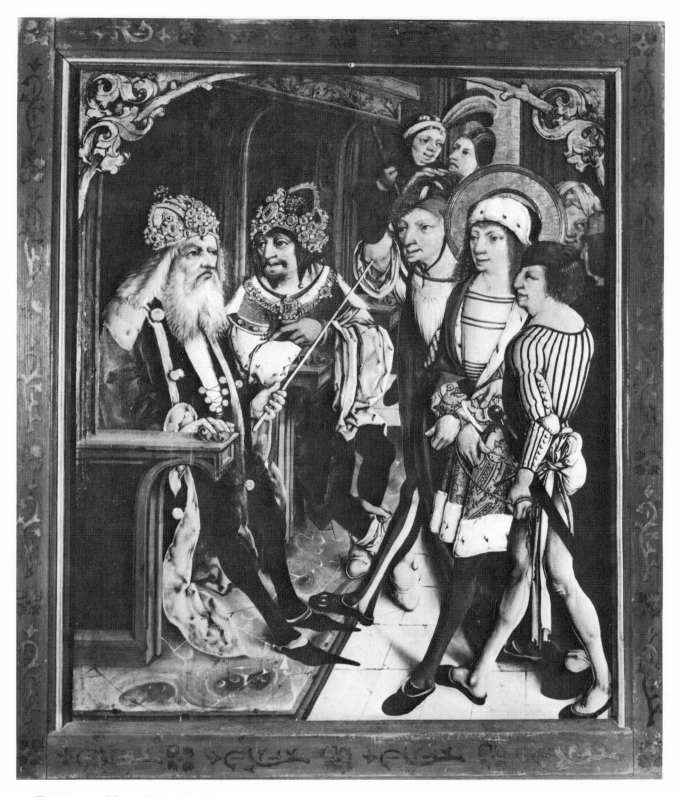

FIGURE 57 Master WB, *St. Sebastian as a Prisoner,* panel painting,
Mainz, Diocesan Museum, ca. 1490

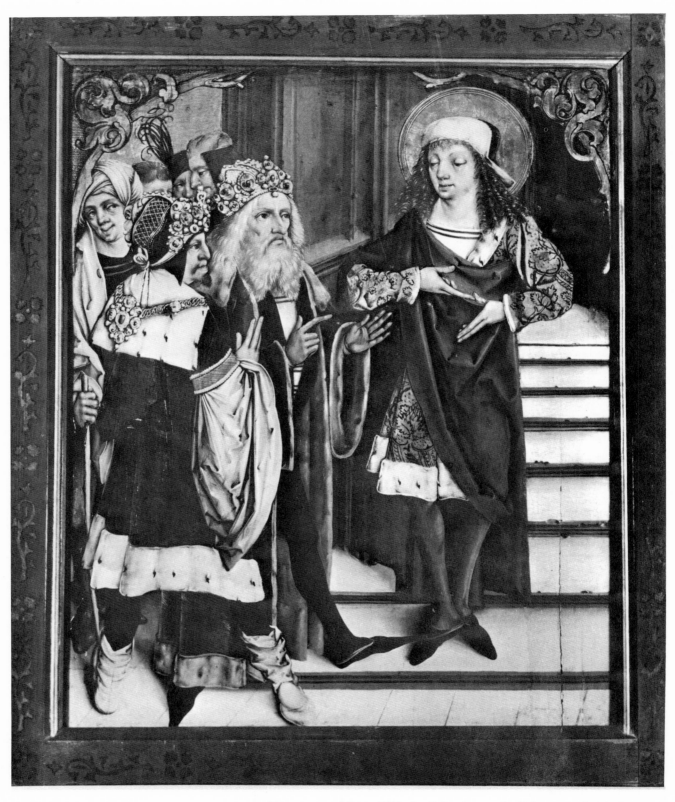

FIGURE 58 Master WB, *St. Sebastian at the Palace,* panel painting,
Mainz, Diocesan Museum, ca. 1490

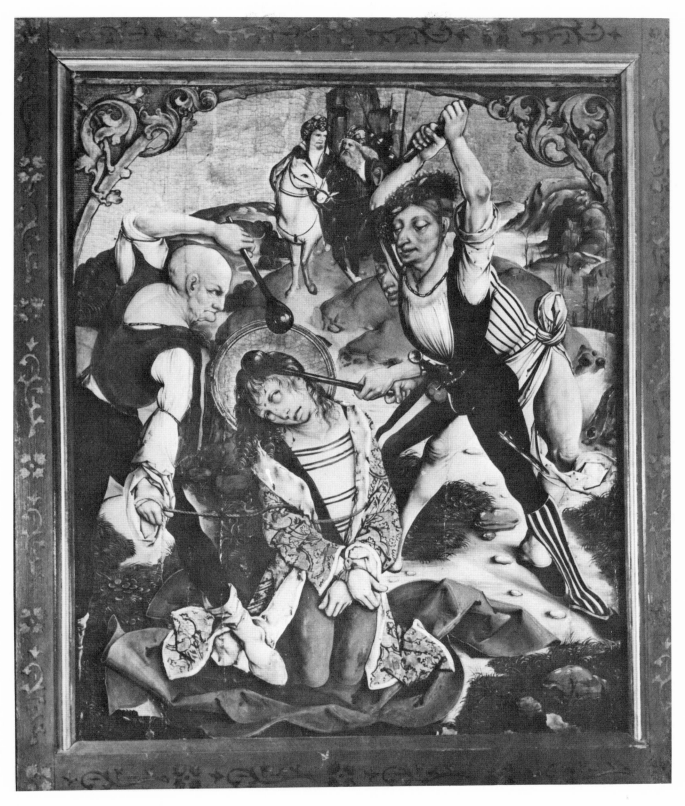

FIGURE 59 Master WB, *Death of St. Sebastian,* panel painting,
Mainz, Diocesan Museum, ca. 1490

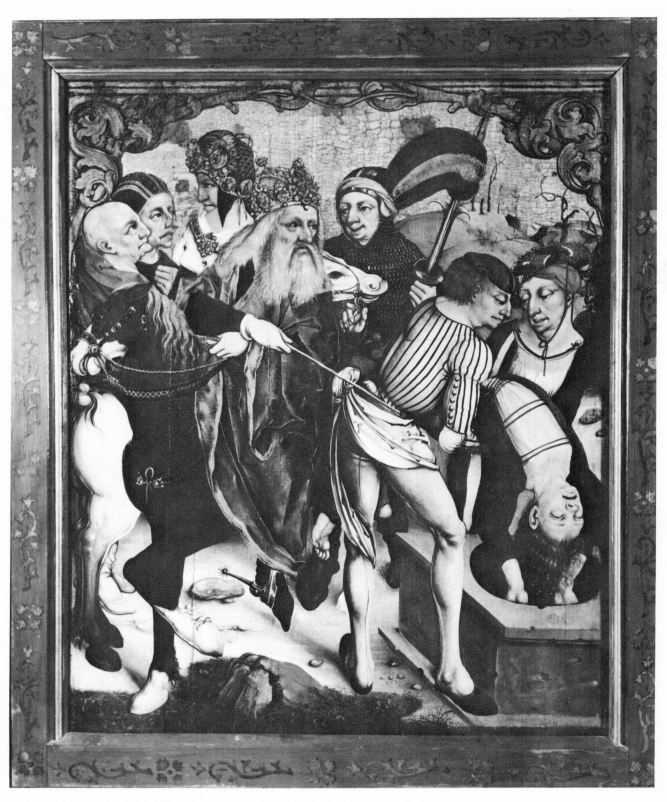

FIGURE 60 Master WB, *St. Sebastian's Body Thrown in the Sewer,* panel painting, Mainz, Diocesan Museum, ca. 1490

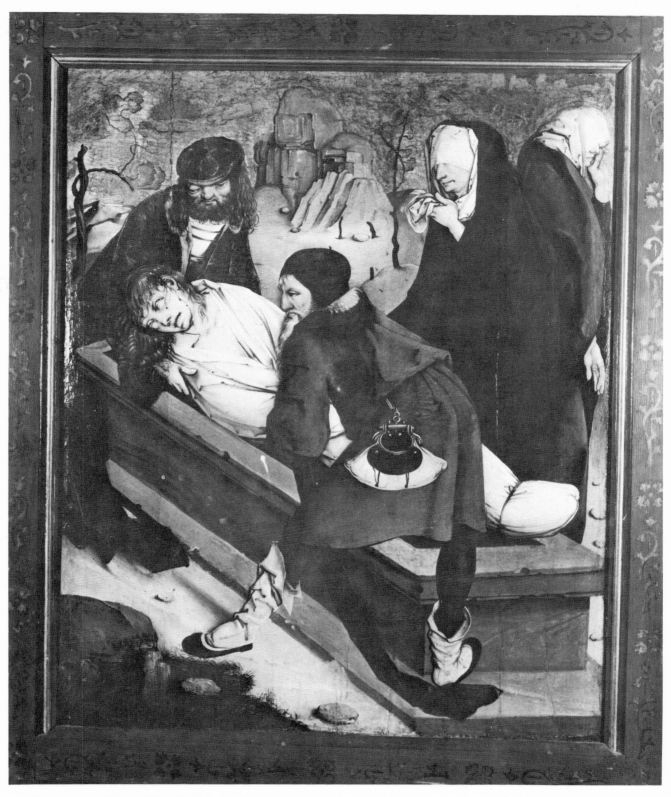

FIGURE 61 Master WB, *Burial of St. Sebastian,* panel painting,
Mainz, Diocesan Museum, ca. 1490

the martyr, led by St. Lucina, found his body and gave it a decent burial (fig. 61).

The eight paintings of the Sebastian group (especially figs. 59 and 60) in their violent and animated realism and their coarse, vulgar types are reminiscent of the paintings of the Karlsruhe Passion by Hans Hirtz.[15] Hirtz's activity probably did not extend beyond 1460, however, and his influence on WB was therefore indirect.

A more direct influence was that of WB's contemporary, the Master of the Housebook, who was also active in the Middle Rhine region near Mainz. The Housebook Master introduced to the Middle Rhine region a highly personal style in which individuals are characterized as empathetic personalities or are represented as penetrating psychological studies. The Housebook Master was a humorist as well as a psychologist, and often even his most tragic scenes have an overtone of the droll or burlesque. The success of his style may have established the value of such an approach and, hence, created a demand for works in a similar style, which would account for WB's close imitation of his colleague's manner. At times WB's figures bear only a superficial resemblance to those of the Housebook Master, and it is difficult to define the specific emotions WB's characters are intended to express. In these cases, WB grasped the appearance but not the substance of the Housebook Master's style. This kind of imitation may account, for example, for the vapid stare of the *Young Woman with the Headdress* (fig. 45). Aiming, perhaps, for the Housebook Master's kind of psychological interpretation, WB overexaggerated the eyes, giving the face quite a different appearance than was intended.

Usually, however, WB achieved great success in transforming the Housebook Master's style into his own. A comparison of one of the Sebastian scenes (fig. 57) with the right wing of the Housebook Master's Speyer Altarpiece in the Augustinermuseum in Freiburg[16] shows the kind of influence the Housebook Master

exerted on WB. The two pictures are similar in their spatial organization, their slightly caricatured facial and figure types, and the particularly poignant gestures and expressions which enliven the narrative. In this instance, Master WB shares with the Housebook Master the ability to interpret a pathetic subject in an intensely personal way.

STAINED GLASS WINDOWS

The greatest achievement of WB's career lies neither in his engravings nor in his panel paintings. His masterpiece is a series of stained-glass windows (figs. 62, 63, 64) which, though only partially preserved, are still to be found in their original location in the choir of the Marienkirche of Hanau.[17] According to an inscription in the church, the building of the choir was begun in 1485; in addition, there is a document regarding the painting of the choir vaults in 1487.[18] These firm dates provide an approximate time, sometime in the late 1480's, for WB's windows.

The windows are very similar in style to the eight Sebastian panels, which must also have been done toward 1490. The style of the Hanau windows is, indeed, so close to the style of the Mainz paintings that the attribution of the windows to Master WB poses no problems. The face of the Christ in the *Pietà* (fig. 62) is almost identical to the face of the dead St. Sebastian in the *Burial* (fig. 61). The figure of St. George (fig. 63) has numerous counterparts in the Mainz panels, although his facial expression, with the mouth slightly askew, derives from the type common to the Housebook Master. The Hanau *Pietà* is an overwhelming work of art; there are few stained-glass windows of the fifteenth century in which such a powerful devotional scene is so fervently presented. Although the motif of Christ's limp body propped up into an almost vertical position was not invented by Master

[15] Lilli Fischel, *Die Karlsruher Passion*, pls. 1–19.

[16] Reproduced in Alfred Stange, *Der Hausbuchmeister* (Studien zur deutschen Kunstgeschichte, 316), Strasbourg, 1958, pl. 94.

[17] There are two windows by Master WB in the Hanau church, each composed originally of twelve panes. Of the twenty-four original panes, sixteen survive. A *Madonna*

and Child dominates one window (see Buchner, *Münchener Jahrbuch*, fig. 21). The upper half of a *St. John the Baptist* and a *St. Catherine* (fig. 64) adjoin the *Madonna*. The second window is dominated by the *Pietà* (fig. 62), with the *St. George* (fig. 63) to the left.

[18] Buchner, *Münchener Jahrbuch*, p. 254, footnote 10.

WB,[19] he employed it in an extremely evocative way. The Madonna, barely restraining her grief, gently supports the pathetic, sagging body. Christ's hands are clenched and the eyes in his emaciated face are partially open; he appears to be suspended in a state between life and death.

Another group of windows, from the parish church in Neckarsteinach—now in the Landesmuseum, Darmstadt (figs. 65, 66)—also seem to be by Master WB, or to be based, at least, on his designs. They date from 1483, about five years earlier than the Hanau windows, and they are much less dramatic and less monumental in composition. Nonetheless, the *St.*

[19] The same arrangement appears, for example, in the Vienna *Lamentation* of ca. 1470 by Hugo van der Goes.

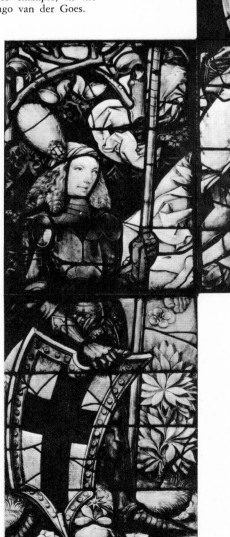

Master WB, *Pietà* and *St. George* from the stained glass windows of the Church of St. Mary in Hanau, ca. 1485–90. This illustration shows the actual arrangement of the details represented in figures 62a, b, and 63a, b.

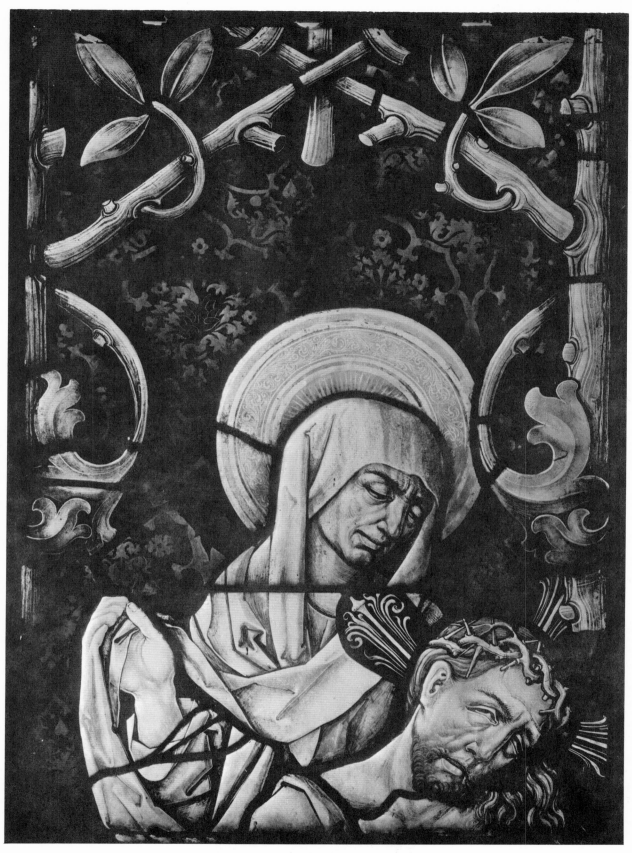

FIGURE 62a Master WB, *Pietà,* stained glass, Hanau, Marienkirche, ca. 1485–90 (detail)

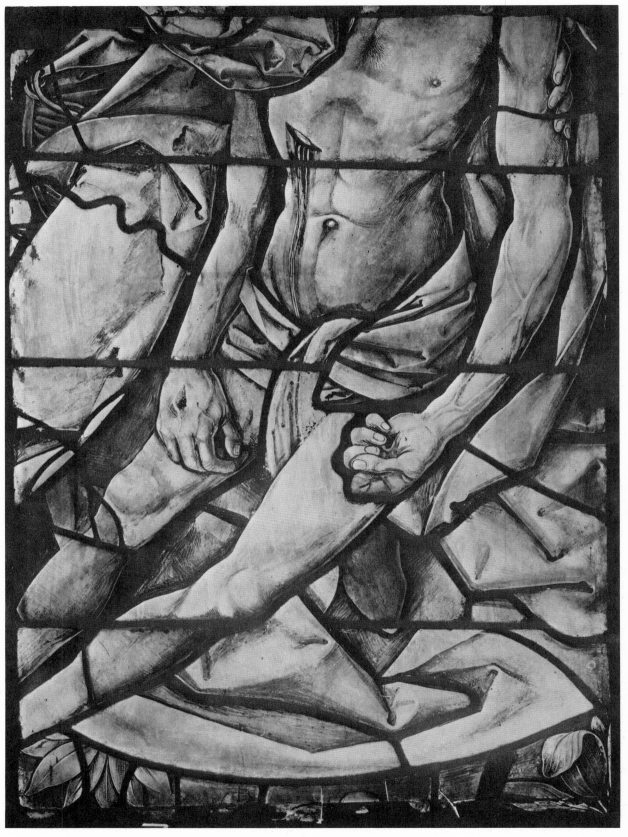

FIGURE 62b Master WB, *Pietà,* stained glass, Hanau, Marienkirche,
ca. 1485–90 (detail)

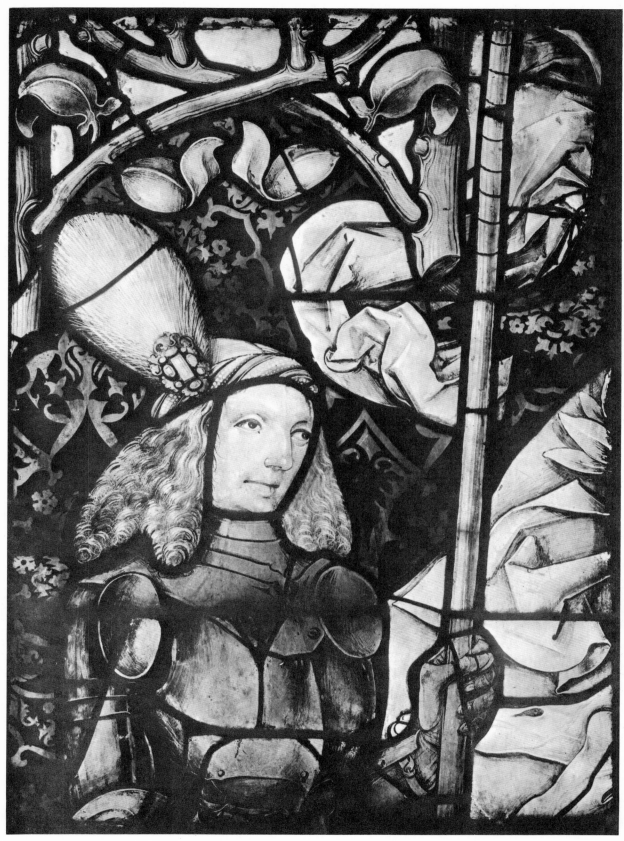

FIGURE 63a Master WB, *St. George,* stained glass, Hanau, Marienkirche, ca. 1485–90 (detail)

Figure 63b Master WB, *St. George,* stained glass, Hanau, Marienkirche, ca. 1485–90 (detail)

FIGURE 64 Master WB, *St. Catherine*, stained glass, Hanau, Marienkirche, ca. 1485–90 (detail)

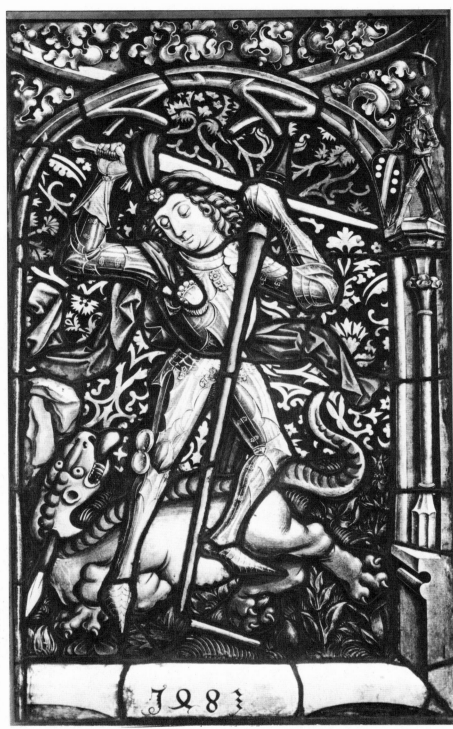

FIGURE 65 Master WB,
St. George and the Dragon,
stained glass,
Darmstadt, Landesmuseum,
1483

George (fig. 65) has the hawklike nose and goggle eyes which are so typical of Master WB's faces. The wife of the donor (fig. 66) has a face which closely resembles some of the faces of the Sebastian paintings (especially the two faces in fig. 55), and the donor himself is endowed with WB's typically large nose and eyes. The hands of these two kneeling donors are also conceived and constructed in WB's characteristic manner—with long, straight fingers and slightly oversized and prominent curved thumbs which spring away from the four fingers (compare figs. 48, 49, 50, 53, 55–61, 64).

FIGURE 66 Master WB, Stained glass window from Neckarsteinach,
Darmstadt, Landesmuseum, 1483

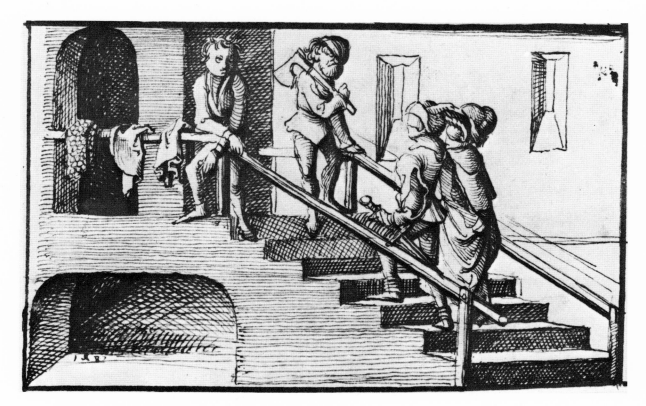

Figure 67 Master WB, *Lewe and Clarissa in the Castle,*
pen drawing from the Herpin manuscript, Berlin, State Library, 1487

BOOK ILLUSTRATIONS,
SKETCHES, AND OTHER WORKS

Among the illustrated German manuscripts
of the fifteenth century in the state library in
Berlin is one which tells the story of Herpin
(or Harpin) of Bourges, an intricate French
legend based on a real personage and historical
events of the late eleventh century, which were
either embellished or transformed in subsequent
written versions. The manuscript is composed
of dramatic episodes which are framed in the
story of Herpin, a sovereign who lost his lands
and whose son Lewe reclaimed them years
later.[20] This tale provided the illustrator with
a wide variety of anecdotal material: love
scenes, courtly ceremonies, skirmishes, am-
bushes, hunting scenes, and intimate genre sub-
jects. There are 188 pen drawings in all, in
light-brown and dark-brown ink. Sometimes
they appear one to a page, but frequently there

are as many as five to a page. The drawings are
interspersed among the first 426 pages; in the
second half of the book, 460 pages in length,
sixty-five pages remain blank, as if to leave
room for illustrations which were planned but
never completed.

Some of the drawings are painstakingly exe-
cuted, while others are rapidly sketched, but
it is clear that they all stem from the hand
of one artist. The first scholar to study the
drawings, Ignaz Beth,[21] attributed them to a
Middle Rhenish master whom he dubbed "the
Master with the Goggle Eyes" (*Der Meister
mit den Glotzaugen*). Buchner, however, noted
their fresh and lively narrative, akin in spirit
to the Mainz Sebastian paintings, and he at-
tributed them to Master WB.[22]

Many of the drawings in the Herpin manu-
script (figs. 67–70) are quickly jotted and
appear to be unpremeditated sketches, spon-
taneous ideas for illustrating each episode. Al-
though the faces and figures are highly stylized

[20] *Historie vom Herzog Herpin van Bourges und seinem
Sohn Lewe* (ms. germ. fol. 464).
[21] Ignaz Beth, "Federzeichnungen der Herpin-Hand-
schrift, in der K. Bibliothek zu Berlin," *Jahrbuch der*

Königlichen Preussischen Kunstsammlungen, XXIX, 1908,
pp. 264–75.
[22] Buchner, *Münchener Jahrbuch,* pp. 263, 269.

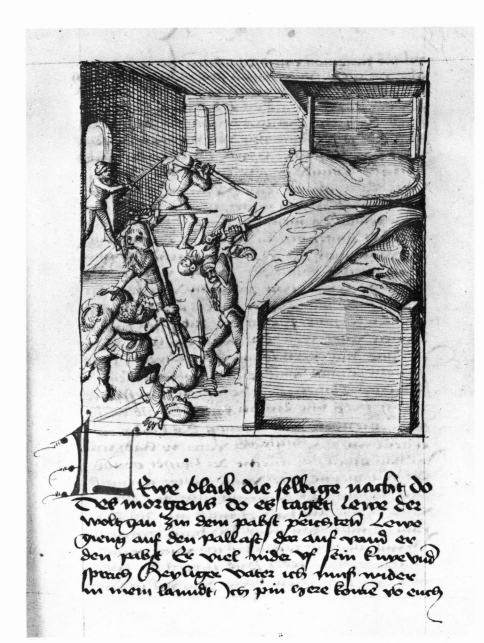

FIGURE 68 Master WB,
Battle in the Bedroom,
pen drawing from the
Herpin manuscript,
Berlin, State Library, 1487

and the scenes are not profound interpretations of the text, the pictures do convey a wonderful sense of the dramatic moment, and they have a lively, unrehearsed character that gives them great charm.

The resemblances between the Herpin drawings and other works by Master WB are numerous. Certainly the name coined by Beth, "the Master with the Goggle Eyes," could apply with equal appropriateness to WB with regard to his engravings and paintings. Furthermore, there are numerous figure types in the drawings which repeat those found in the

Sebastian paintings. For example, the executioner who is clubbing St. Sebastian to death in one of the Mainz panels (fig. 59) is very like the figure of Lewe in one of the manuscript drawings (fig. 68). Both figures have the same wide stance and bony knees, and the same firm, two-handed grip on their weapons, although Lewe swings a sword rather than a cudgel. Landscape backgrounds in the Herpin drawings (fig. 69), like those in the Sebastian panels (fig. 61), are composed of bare, dead trees in a barren, rock-strewn terrain. Finally, one of the drawings in the Herpin manuscript

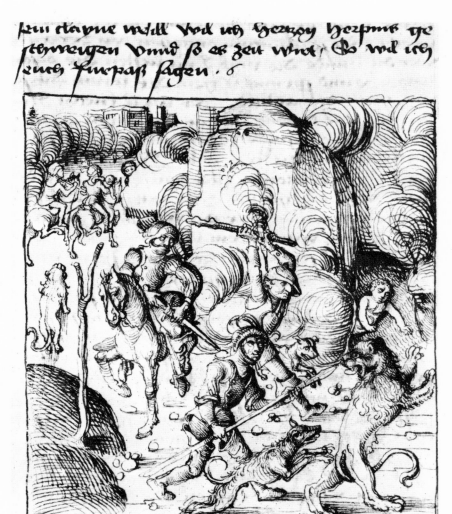

FIGURE 69 Master WB,
Baldwin's Discovery of Lewe,
pen drawing from the
Herpin manuscript,
Berlin, State Library, 1487

bears the date 1487, written unobtrusively in the lower left corner (fig. 67). This date is in full accord with the stylistic evidence for dating the drawings about the time of the Sebastian panels, which we have already placed in the late 1480's.

In addition to the silverpoint drawing in Bayonne (fig. 52), five other individual drawings have been attributed to Master WB. Three of them, all in the University Library, Erlangen (figs. 71–73), are so close in style to the drawings of the Herpin manuscript that they clearly belong to the *oeuvre* of Master WB.[23] The first two, a *Crucifixion with St. Wolfgang and St. Christopher* (fig. 71) and a *Martyrdom of St. Ursula* (fig. 72), are either preliminary sketches for the central panel and wing of a

folding altarpiece, or else sketches of an altarpiece the artist had seen and admired. The *Crucifixion* even has indications of the gothic ornament (*Sprengwerk*) which frequently decorates the upper borders of German altarpieces. The third drawing in Erlangen, an *Amorous Young Couple* (fig. 73), was clearly inspired by the Housebook Master.[24] A comparison of the male figure with the equivalent figure in the Housebook Master's *Young Man and Death* (Lehrs 53) shows how closely Master WB imitated the prototype. The Erlangen drawing is so close in its penmanship to the Herpin illustrations, however, that its attribution to WB can not be doubted.

Two other drawings, ascribed to Master WB in the 1920's, are not, in the present writer's

[23] See Elfried Bock, *Die Zeichnungen in der Universitätsbibliothek Erlangen,* I, Frankfurt, 1929, p. 16, nos. 38, 39, 40.

[24] Willy F. Storck, "Eine Zeichnung des Meisters der Herpinhandschrift," *Monatshefte für Kunstwissenschaft,* III, 1910, p. 346, pl. 80.

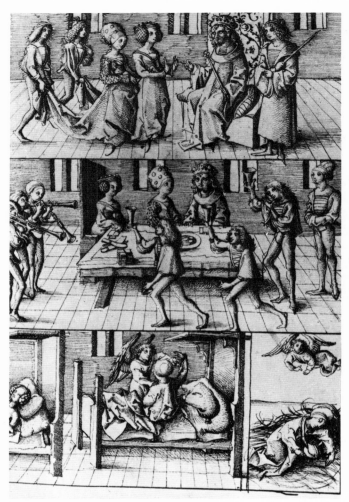

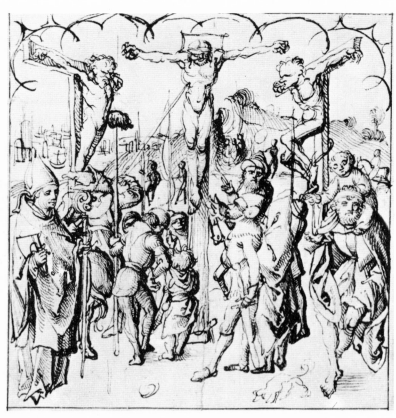

FIGURE 71 Master WB, *Crucifixion with St. Wolfgang and St. Christopher,* pen drawing, Erlangen, University Library, ca. 1487–90

FIGURE 70 Master WB,
Three scenes from the Herpin Manuscript,
pen drawing, Berlin, State Library, 1487

opinion, close enough to WB's style to justify the attribution. One, a drawing in Munich, attributed to WB by K. T. Parker,[25] appears to be an imitation of Schongauer's so-called "Moorish" female type. It has no characteristics which would distinguish it as a work by Master WB.

The second (fig. 74), a drawing in Vienna attributed to Master WB by E. Tietze-Conrat,[26] also seems closely related to and imitative of Schongauer. The three heads in this drawing

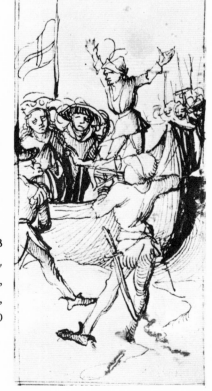

FIGURE 72 Master WB
Martyrdom of St. Ursula,
pen drawing, Erlangen,
University Library,
ca. 1487–90

[25] K. T. Parker, "Quelques Dessins de l'École Alsacienne du XV. et du XVI. Siècle," *Archives alsaciennes de l'histoire de l'art,* II, 1923, pp. 65–66, fig. 24. The drawing is reproduced in Franz Winzinger, *Die Zeichnungen Martin Schongauers,* Berlin, 1962, no. 57. Winzinger correctly suggests that the drawing is an exacting copy after a lost early drawing by Schongauer.

[26] E. Tietze-Conrat, "Monogrammist WB, Studies of a Woman," *Old Master Drawings,* II, 1927, pp. 26–28, pl. 31.

FIGURE 73 Master WB, *Amorous Young Couple,*
pen drawing, Erlangen, University Library, ca. 1487–90

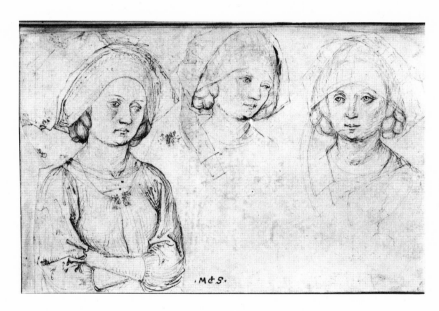

FIGURE 74
Middle Rhenish Master,
Study sheet with three
female heads, pen drawing,
Vienna, Albertina,
ca. 1490–1500

appear to be studied from life and to represent the same person seen from three different angles. Mrs. Tietze-Conrat's suggestion that WB would have made this kind of careful study before embarking on an engraving such as the *Lady with a Jeweled Cap* (fig. 42) is intriguing. This drawing is much more delicate, however, than any of the WB engravings or any of his securely attributed drawings. The woman seems much more refined than WB's women usually are, and her face has none of the stylized traits which usually characterize WB's female faces. Mrs. Tietze-Conrat eventually abandoned this attribution; five years after she first published the drawing as a work by Master WB, she served as a co-author of the Albertina catalogue of German drawings in which the drawing is identified merely as "Middle Rhenish Master, end of the fifteenth century." [27]

[27] Hans Tietze, E. Tietze-Conrat, O. Benesch, K. Garzarolli-Thurnlackh, *Beschreibender Katalog der Handzeichnungen in der Graphischen Sammlung Albertina,* VI (Die Zeichnungen der deutschen Schulen), Vienna, 1933, no. 24.

FIGURE 75 Master WB, Woodcut from the
Saxon Chronicle, Mainz, 1492

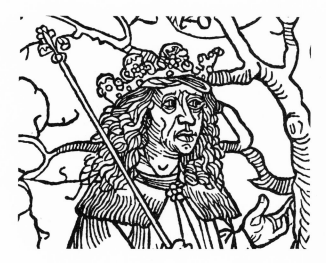

FIGURE 76 Master WB, Woodcut from the *Saxon Chronicle*, Mainz, 1492 (detail)

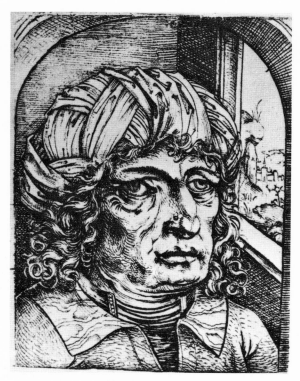

FIGURE 77 Master WB, *Old Man in a Turban*, engraving, ca. 1485–87

We have established that Master WB was a painter, a book illustrator, and a designer of stained glass, as well as an engraver. Buchner proposed that WB also designed the woodcuts which illustrate the *Saxon Chronicle* (*Chronecken der Sassen*), published in Mainz by Peter Schöffer in 1492.[28] Certainly the date and place of publication agree with what we know of WB's activity. It is extremely difficult, however, to compare woodcuts of the fifteenth century with works in other media. Woodcuts were produced by a team—designer and cutter—and the designer had little control over the quality or character of the cutting. The technical limitations of the medium also imposed restrictions on the degree of fidelity that even the most conscientious cutter could achieve. Since knives and chisels were used in cutting the wood block, the lines in the early book illustrations tend to be rather rigid and angular.

When we examine the woodcuts of the *Saxon Chronicle,* however, some of WB's characteristics emerge distinctly, even though the cutter's technique comes between us and the artist's original design. For example, the face of the king in one of the woodcuts (fig. 75) is strik-

ingly similar to the face of the old man in one of the WB engravings (compare figs. 76 and 77), and the unique drawing of the hands with accented thumbs is an unmistakable sign of WB's involvement. It thus appears that in addition to his works in other media, Master WB also made at least one foray into the realm of woodcut designing and was active for at least a short time in the most famous business of Mainz in the fifteenth century, the printing of books.

Like Master LCz, WB was a creative personality and an important forerunner of Albrecht Dürer, involved in a variety of artistic endeavors. Recent research into the early history of graphic art has shown that engravers should not be studied in isolation or rigidly segregated from the rest of art history, since so many of them, like our two masters, were part of the mainstream of stylistic development.

[28] See Buchner, *Münchener Jahrbuch,* figs. 38–41; Leo Baer, *Die illustrierten Historienbücher des XV Jahrhun-* derts, Strasbourg, 1903, pp. 161–72; Schramm, *Bilderschmuck,* XIV, p. 9, pl. 128:614.

Index

INDEX